SECRET NEWCASTLE

Ken Hutchinson

AMBERLEY

Acknowledgements

Thanks to my wife Pauline for proofreading the book. Thanks to Tom Poad and the team at Amberley for asking me to write the book and for helping me to produce it. Thanks to all the City Guides for sharing their knowledge and also for sharing their enthusiasm and encouragement to promote our special city or 'Toon' of Newcastle. Special thanks go to my wife Pauline, sons Peter and David and granddaughter Isla for their continued support and encouragement and for bearing with me while I went missing to take the photographs and write the text.

I would like to dedicate the book to all those responsible for proving the sculptures, monuments artworks, plaques, buildings and other objects featured in the book and also for the many more I have been unable to include. Keep up the good work.

First published 2015

Amberley Publishing
The Hill, Stroud, Gloucestershire, GL5 4EP
www.amberley-books.com

Copyright © Ken Hutchinson, 2015

The right of Ken Hutchinson to be identified as the Author of this work has been asserted in accordance with the Copyrights, Designs and Patents Act 1988.

ISBN 978 1 4456 4127 0 (print)
ISBN 978 1 4456 4139 3 (ebook)

British Library Cataloguing in Publication Data.
A catalogue record for this book is available from the British Library.

Typesetting by Amberley Publishing.
Printed in Great Britain.

Introduction

Secret Newcastle concentrates on certain features of Newcastle's past and present that are all visible today. Many of the subjects featured in the book are 'invisible', yet are in full view to everyone. In other words, people walk past them everyday taking them for granted. This was certainly true in my case, as I discovered a few years ago as I trained to be a Newcastle City Guide. All these features were pointed out to me, and despite thinking I knew Newcastle like the back of my hand, having lived and worked here for well over fifty years, my eyes were well and truly opened. Most of the photographs I have used show plaques, statues, sculptures, artworks and buildings that I have walked past for years without realising their significance, both locally and nationally. Newcastle and the surrounding areas have produced some of the most influential people in British and world history, as well as great inventors, musicians, artists and politicians. The city has welcomed a wide range of British and international visitors including many visits from royalty. All of this is recorded in the streets around us, in the centre of Newcastle, if you know where to look.

The pictures in the book have been arranged to follow five different walking routes around Newcastle. The first four start from Grey's Monument in the centre of the city. The first covers the north area from Northumberland Street to the University. The second travels west to include the Newgate Street, Gallowgate and West Walls areas. The third goes to the southeast to New Bridge Street Market Street, Cathedral/Castle area and the Stephenson Quarter. The fourth continues south down Grainger Street and to the Westgate Road area and the last is based on the Quayside starting at the Guildhall and finishing beyond the Millennium Bridge.

As with any book of this type there will inevitably be some errors for which I apologise in advance, as I have not been able to check every name, date or detail at the original source.

All the royalties from this book will be divided between St Oswald's Hospice in Gosforth and the Sir Bobby Robson Foundation.

Earl Grey, Grey Street

 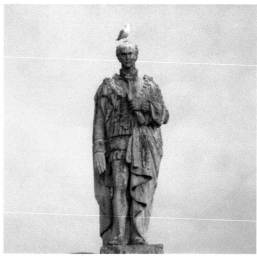

Above left: Grey's Monument is viewed from Grainger Street across a large plaque in the centre of the street dedicated to Richard Grainger, the developer and visionary for the famous Grainger Town streets and buildings.

Above right: Earl Grey, famous for his tea as well as being the prime minister responsible for the Great Reform Act of 1832, stands proudly on top of his column at the top of Grey Street. A seagull takes advantage of the elevated perch to take in the views of the city.

Charles Grey is known throughout the world for giving his name to Earl Grey tea rather than for being the former British prime minister responsible for changing the democratic makeup of Britain by introducing the Great Reform Act of 1832. The unique tea was blended with bergamot oil to offset the high level of lime in his local water supply in Northumberland, and it became popular with guests at 10 Downing Street. He is also remembered in the film *The Duchess* as being the father to the Duchess of Devonshire's illegitimate child whom he brought up himself, along with his fifteen children by his future wife Mary, at Howick in Northumberland. The statue was erected in 1838 when he was still alive, but he did not come to the unveiling ceremony as he wasn't that keen on Newcastle. The head you see today is not the original and was put in place by the sculptor Roger Hedley (son of the famous artist Ralph Hedley) in 1947 after it was struck by lightning in 1941 during the Second World War. It is said that the head was retrieved by a local shopkeeper who put it in his shop window with a sign saying the prices in the shop were so low that Earl Grey had come down to see them. It is possible to climb the 164 steps up to the top of the monument to gain a spectacular view of the city.

Newcastle City Guides arrange openings during the summer months on certain days details can be found at www.newcastlecityguides.org.

Northumberland Street Sculptures

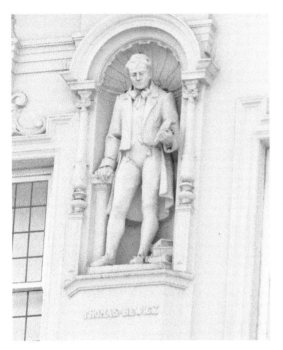 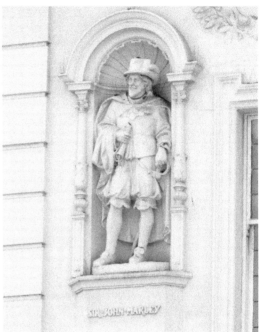

Above left: About halfway down Northumberland Street on the west side are four figures, with links to Newcastle. Thomas Bewick the famous wood carver.

Above right: Sir John Marley, mayor during the Civil War.

For many decades, four figures have looked down upon shoppers on Northumberland Street. They have seen many changes over the years, not least the change from being one of the busiest streets in terms of traffic, when the main road to Scotland, the A1, followed this route through Newcastle until the 1970s, to becoming one of the busiest pedestrian shopping streets in Britain. Thomas Bewick is the famous wildlife engraver from Mickley near Gateshead whose house Cherryburn is preserved by the National Trust. He had strong connections with Newcastle and both lived and worked in Newcastle during his lifetime. Sir John Marley (1590–1673) is a former mayor of Newcastle. He is remembered mainly because he was the mayor at the time of the Great Siege of Newcastle in 1644 during the Civil War when Newcastle backed the Royalists. He refused to surrender to the Scottish Army, and when they threatened to destroy St Nicholas's lantern tower he filled the tower with Scottish prisoners. When the Scots finally broke through the town walls he held out in the castle keep for some days before escaping to France. He was criticised by some for holding out too long as it caused a lot of hardship to the inhabitants of Newcastle, but despite this he was subsequently re-elected as mayor.

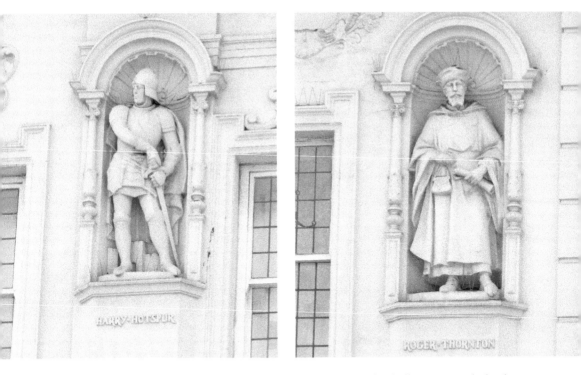

Above left: Harry Hotspur, made famous by Shakespeare, has a football team named after him.

Above right: Roger Thornton is Newcastle's equivalent of Dick Whittington, arriving with nothing and ending up as rich merchant and mayor.

The building frontage, including the figures, was built for Boots the Chemist in 1912. Roger Thornton is often referred to as Newcastle's version of Dick Whittington. He is said to have arrived at the West Gate of Newcastle with only the shirt on his back and then became the richest man in Newcastle. He was a well-respected merchant who became mayor of Newcastle and a great benefactor to both the church and residents of the town. He founded a hospital or almshouse for poor men and women immediately to the east of the present guild hall known as St Katherine's Hospital, or, as the locals called it, Thornton's *Maison de Dieu* (house of God). He is still remembered by a magnificent Brass Plaque in St Nichols' Cathedral, dating from around 1429.

Harry Hotspur is even more famous as he features in William Shakespeare's *Henry IV, Part 1* as well as having a Premier football team (Tottenham Hotspur) named after him. He was the Duke of Northumberland's son, Sir Henry Percy (1366–1403), who was known for his bravery as well as being a bit of a 'hothead'. He was helping to defend Newcastle from the Scots when he accepted a challenge from the Earl of Douglas to a single combat outside the New Gate. During the conflict it is said Harry Hotspur fell and lost his pennant to the Earl of Douglas, who then set off to Scotland with it. Harry Hotspur then raised an army in Newcastle and pursued Duncan to Otterburn where the famous Battle of Otterburn took place in August 1388. The Earl of Douglas was killed, but Hotspur was captured and later ransomed.

The Orphan House, Northumberland Street

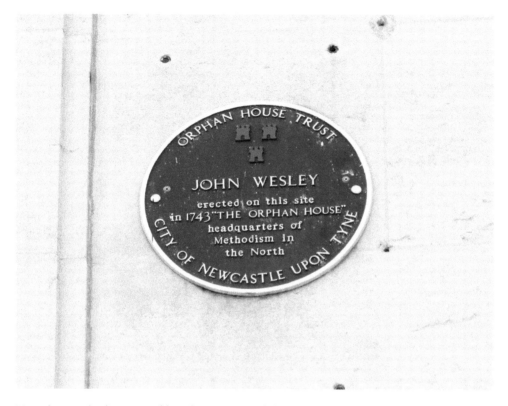

Next door to the figures is a blue plaque to record that John Wesley, the founder of Methodism, set up an Orphan House on this site in 1743.

Next door to the famous four on Northumberland Street is a blue plaque to commemorate the site of the 'Orphan House' erected in 1743 by John Wesley and which later became the headquarters of Methodism in the North. John Wesley himself had a small office here in the roof space which he used on his many visits to Newcastle. He founded Methodism with his brother Charles and, interestingly, he was never a Methodist minister but remained a minister in the Anglican Church until his death in 1791, aged eighty-seven. Although called Orphan House, it did not operate as an orphanage with resident orphans; it was more of a meeting place and centre for religious training. It also had a chapel and accommodation for preachers as well as offering help to the poor, including orphans. The building was replaced in 1820 when the present Brunswick Methodist Church was built nearby in Brunswick Place to house a growing congregation of Methodists. John Wesley used to travel extensively between the three main centres in England of his developing evangelistic movement in Newcastle, Bristol and London. He also travelled to Ireland and North America.

Stone Sculptures, Northumberland Arms

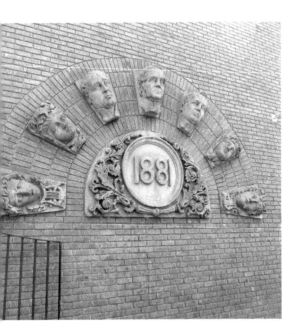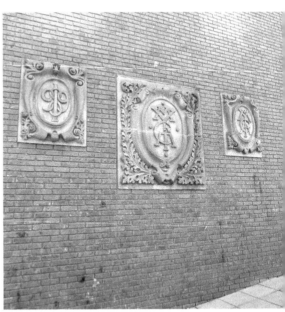

Above left: A number of stone sculptures are to be found on the side wall in Pudding Chare, off Northumberland Street, beside the entrance to the Northumberland Arms.

Above right: The stones came from buildings lost when Eldon Square Shopping Centre was built. This picture shows stones from the former YMCA on Blackett Street.

When Eldon Square Shopping Centre was being constructed in the 1970s, a number of buildings were demolished to make way for it. Some of the decorative features of these buildings were salvaged and stored safely. Later they were incorporated into the wall built between the new Eldon Square entrance onto Northumberland Street and the Marks & Spencer store known as Prudhoe Chare. Two of the original YMCA stone-carved crests, together with a date stone of 1901, were rescued from the YMCA building that dominated the corner of Blackett Street for seventy years, fronting onto Grey's Monument.

The entrance into the Northumberland Arms is through a recycled doorway over a century old. A little further up, a date stone of 1881 is surrounded by busts of famous people thought to include Thomas Bewick and George Stephenson as well as other classical characters. It is commendable that these features have been retained as an example of the rich decoration of Victorian buildings that were so commonplace at the time, in contrast to modern buildings that lack this individual ornamentation and craftsmanship. The name Prudhoe Chare retains the link with the former street that used to link Northumberland Street with Percy Road, Prudhoe Street. 'Chare' is the traditional name for a narrow alleyway in Newcastle.

Northumberland Road Murals

The mural depicting important images linked to Newcastle was erected originally on the side of BHS in 1974 and was produced by the artists Henry and Joyce Collins. It depicts Newcastle through the ages using words and images. Monkchester is thought to be what Newcastle was called after the Romans left in AD 410 and before the 'New Castle' was built in 1078 by the Normans. It is believed that a Saxon settlement grew up around the site of the former Roman fort. Excavations provided evidence of a building thought to be a Saxon church or chapel surrounded by a large burial ground on the site of the Roman fort. The red shield containing three images of castles is Newcastle's motto and forms part of its coat of arms. The bearded head represents the Tyne God and includes coal being burnt in a brazier above his head; a pick and fishes are included above his hair and Neptune's trident is included on either side. Two sailing ships are shown – the upper one represents a trading ship as Newcastle was a major shipping centre with many links to European ports, and the other is a collier brig, 1704–1880, which was used to export coal to London. Oceanus refers to the Roman altar to the God Oceanus, possibly from the original Roman bridge that was found during dredging of the river when the Swing Bridge was under construction in the

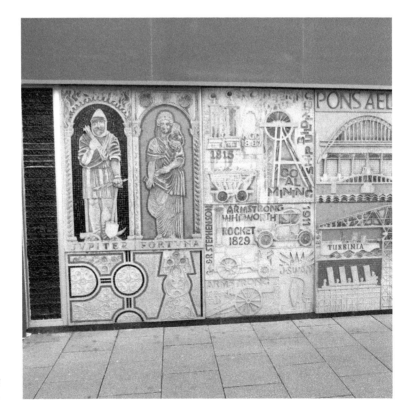

This is part of the three murals on the side of the Primark store that record the history of Newcastle. Three of the Tyne Bridges are shown together with the famous ships of *Turbinia* and *Mauretania*.

1870s. A Roman coin featuring the emperor Hadrian is also depicted here with *Hadrianus Augustus* inscribed on the coin. The anchor represents links with shipping; the propeller, cog and hammer represent industry on the Tyne. The seahorse and trident are also taken from the city's coat of arms and are found all over the city, not least on the top of the Civic Centre.

Jupiter and Fortuna are two Roman gods that had many altars and statues dedicated to them during the Roman occupation of Tyneside, and many can be seen in the Great North Museum. Jupiter is seen here holding a lightning bolt and a pit shovel; in the other hand are arrows. The goddess Fortuna was meant to give you good luck and is depicted holding a *cornucopia* (horn) of plenty. Her right hand is on the tiller of a boat to direct you on a safe route through the voyage of life. To the right is an area given over to local industries and features two safety lamps that were invented in 1815 following the Felling pit disaster that claimed ninety-two lives. The first is the Davy lamp, invented by Sir Humphrey Davy, and the second, by George Stephenson, is known as the Geordie lamp. A Pit Head wheel is shown with 'Coal Mining' written under it. In between is a glass cone similar to the surviving one at Lemmington, built for the Northumberland Glass Co. in 1797. A black wagon is also featured carrying coal on the wagonways which were used before railways were developed. The wagons were horse-drawn up hills and on downhill stretches gravity was used. They often had a rider sat on top using the handbrake to control the speed. A 1911 car built at Armstrong Whitworth's factory in Elswick is featured beside one of Armstrong's 12-Pounder Guns built for the Royal Artillery. The famous locomotive the *Rocket*, built in 1829 at R & G Stephenson Works in Newcastle, is featured beside Joseph Swan's invention of the incandescent electric light bulb, first seen in Newcastle in 1878. The Roman bridge of Pons Aelius was built around AD 122 by the Emperor Hadrian and named after him. 'Pons' means bridge and 'Aelius' is Hadrian's family name. The Roman fort built on the site of the present castle, around AD 190, was also called Pons Aelius. Depicted underneath 'Pons Aelius' are the Tyne Bridge, High Level Bridge and the Swing Bridge (which was built on the same site as the original Roman bridge). Below the large Hammerhead crane is the largest and fastest liner of its day, the *Mauretania*, built by Swan Hunters in 1906. Featured also is the equally famous ship the *Turbinia*, also built at Wallsend in 1896 and developed by Charles Parsons, who developed turbines to power ships and later electricity generators. The next panel features some of Newcastle's famous buildings and architects: the Lantern Tower of St Nicholas Cathedral; the Castle Keep; All Saints church by David Stephenson; Grey's Monument and the Theatre Royal by John and Benjamin Green; and St Thomas' church by John Dobson, Richard Grainger, John Stokoe and William Newton. Britannia is represented on a coin. A statue inscribed *Brigantia* refers to pre-Roman tribes in the area and the snake-like creature represents an illustration from the Lindisfarne Gospels. The date 1882 refers to the year that Newcastle became a city. Thomas Bewick's Swan is also featured below a depiction of three Roman goddesses. The right panel shows two figures below the word 'Geordie'– the nickname for locals in the Newcastle area. The figure on the red background represents a shipyard welder and the figure on the black background a miner. Below them is a depiction of one of Tyneside's lost industries that is still remembered in the song 'The Keel Row'. Keelmen transported coal and other goods on shallow bottomed boats called keels to colliery brigs downriver.

Burt Hall, Northumberland Road

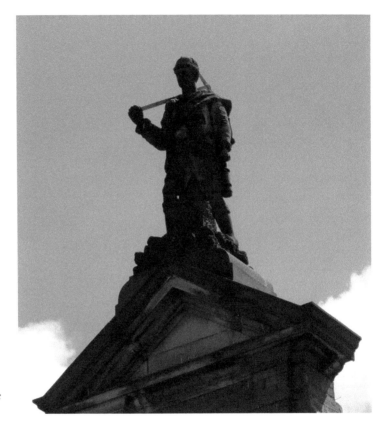

Opposite the City Hall, Burt Hall was built in 1885 and named after the famous Northumbrian Thomas Burt, the first miner to become an MP.

Burt Hall was erected in 1885 by the Northumberland Miners in recognition of Thomas Burt MP – the first working miner to be elected as an MP. He was born in Backworth and worked in the pit from an early age. He was a self-educated man and worked his way up through the Northumberland Miners Union to become the general secretary – a post he held for forty-eight years. Burt also became secretary of the board of trade in 1892, and later became 'Father of the House of Commons'. He was MP for Morpeth from 1874–1918. The statue on the top is based upon a famous painting by renowned local artist Ralph Hedley called *Going Home*; the figure is of the younger miner featured in the painting and is reproduced here standing on a mound of coal with a pit axe over his shoulder and a safety lamp in his other hand, which would suggest he was a 'hewer' who would work at the coal face using his pick to extract the coal. Thomas Burt is buried in Jesmond Old Cemetery on Jesmond Road, not far from the Bainbridge Family (of the department store) and his gravestone has recently been restored to its former glory. Newcastle City Guides do regular guided tours of Jesmond Old Cemetery, which of course feature Thomas Burt's burial place.

Dame Allan Statue, College Street

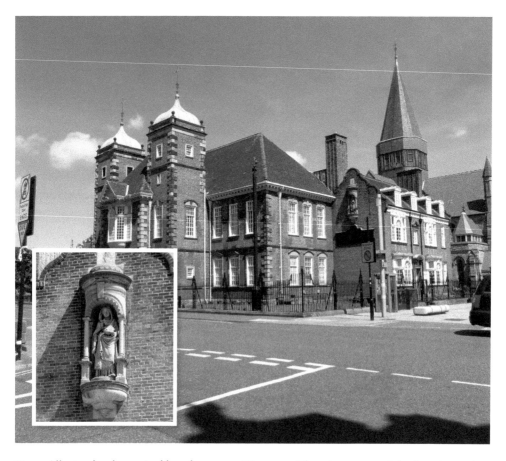

Dame Allan's school was sited here between 1883–1935. There is a statue of the founder set in a wall close to Northumberland Road.

Dame Allan founded Dame Allan's Schools in 1705. Not many people are aware that the original school was founded to educate the poor, and that the money came from selling tobacco. Dame Allan's husband ran a tobacco shop in Newcastle, but he was not a good businessman and died leaving them in debt. Eleanor Allan and her son Francis took over the business and made it a considerable success. They bought the Village Farm on Wallsend Green in 1700. Sadly, Francis, who was unmarried, died before her, and she decided to use the money from the tenancies of the farm to establish and run a school, administered by trustees, for forty poor boys and twenty poor girls from the parishes of St Nicholas and St John. Dame Allan died in 1709 – the year that the school opened. The building in College Street was used as Dame Allan's School between 1883–1935, with the boys on the first floor and girls on the ground floor. It was designed by R. J. Johnson.

South Africa War Memorial, Haymarket

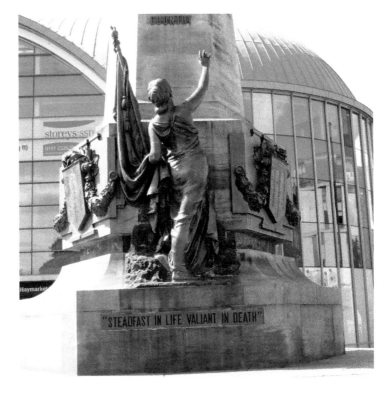

The Boer War memorial is situated immediately outside Haymarket Metro station and had to be moved during construction. The wings of the Victory angel had to be replaced in fibreglass to reduce the weight of the sculpture when it was reinstated.

"STEADFAST IN LIFE VALIANT IN DEATH"

This is the oldest war memorial in Newcastle city centre. It dates from 1907 and was sculpted by Thomas Eyre Macklin. It commemorates the famous soldiers of the 'Fighting Fifth' – the 5th Regiment of the Northumberland Fusiliers who died in the 1899–1902 South Africa Boer War. On the top of the tapered octagonal column is a statue of a Winged Victory, and at the foot of the column is another figure of a young lady with an unfurled flag, meant to represent Northumberland with the words 'Steadfast in Life Valiant in Death' below. A number of plaques give the names and ranks of 373 men who lost their lives, many of whom were volunteers, which was unusual at that time. On one side it states that 'the monument was erected to the memory of the officers, non-commissioned officers and men of the Northumberland Regiments who lost their lives in the South African War 1899–1902 Erected by their County and Comrades'. A number of Latin inscriptions are included: *'Quo Fata Vocant'* meaning 'Whether the Fates Call' which was the motto of the Fighting Fifth.*'Dulce et Decorum Est Pro Patria Mori'* meaning 'Great and Glorious to Die for your Country'.

In 1975, when the Haymarket Metro station was under construction, the monument was removed and the winged angel had to have its wings replaced by fibreglass copies to reduce its weight.

St George's Statue, St Thomas' Church

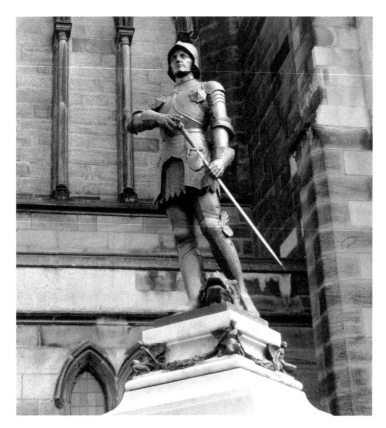

St George, the patron saint of the Northumberland Fusiliers, overlooks St Mary's Place from the war memorial outside John Dobson's first and possibly best church design.

This statue forms part of another war memorial in the Haymarket area and is a monument in Portland Stone featuring St George, the patron saint of the regiment of the Northumberland Fusiliers. It lies to the south of St Thomas's church close to the entrance. It was unveiled in 1924 to the 6th Battalion (Territorial) who fought in the First World War. A Second World War dedication was added to commemorate the dead from the 43rd and 49th Battalion Royal Tank Regiments. The sculptor was John Reid, who also designed the North Shields war memorial in Hawkeys Lane. The church of St Thomas the Martyr was built in the grounds of the former Mary Magdalene Hospital to replace the chapel to St Thomas the Martyr that stood on the north side of the old Georgian Tyne Bridge, demolished to make way for the Swing Bridge. It was designed by John Dobson and was his first church, and many think his best. It was built in the Gothic Revival style, with tall pinnacles and lancet windows (tall, thin with pointed arches); it also has an open bell tower. It is still black from smoke and is peculiar as it does not have a parish but serves a number of different groups within the church. The vicar is known as a 'master', and each year they hold a special service for all people who have donated their bodies for medical research.

The Response Memorial, Barras Bridge

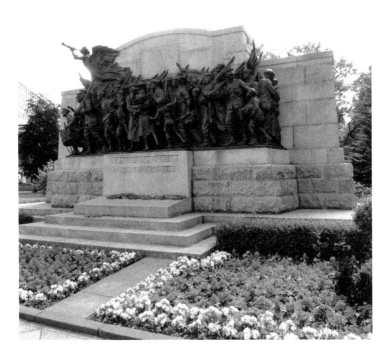

Many believe this is the best war memorial in England. It is a narrative sculpture telling different stories of the individuals called to arms in the First World War. It starts with enthusiasm and ends in regret.

The Response 1914 is considered to be one of the best war memorials in the country. It was commissioned by Sir George, a ship owner and former mayor of Newcastle, and Lady Renwick, as a gesture of thanks that all five of his sons returned safely home after the First World War. The sculptor was the internationally famous Sir W. Goscombe John R .A. and was unveiled by the Prince of Wales on 5 July 1923 in front of a massive crowd of dignitaries, servicemen and the general public. It is described as a narrative sculpture telling the story of the different emotions felt by people at the general call to arms in 1914. It is in fact based upon the actual march through Newcastle by the famous 'Fighting Fifth' regiment of the Northumberland Fusiliers in October 1915, who marched past this very spot on route from Gosforth Park, where they had been training, to board trains at the Central Station on route to France and Belgium. The drummer boys and men at the front are full of enthusiasm, and a soldier a little way back says goodbye to his sweetheart surrounded by young boys joining in with the parade. At the back is a very telling image of a father holding a baby for the last time as he hands the child back to his wife as another child holds onto the back of her skirt as if they all knew what was to happen. The drummer boy at the front is thought to be modelled on an actual drummer boy from the Coldstream Guards called Wilfred John Mathews.

Town Moor Boundary Market, Barras Bridge

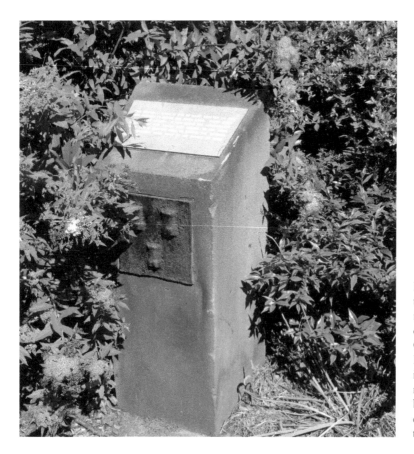

Hidden among the shrubbery in the grounds of the Civic Centre, close to Barras Bridge, is a marker to record how far buildings have encroached on the Town Moor.

Hidden away in the undergrowth between the Civic Centre and Barras Bridge is a boundary marker stone for the Town Moor. The Town Moor now starts further up Claremont Road beyond Exhibition Park and the motorway, before you get the feeling you are in the wide open space of the Town Moor. This shows how much the Town Moor has been encroached upon since the marker stone was installed in the eighteenth century. These stones were placed at various locations to define the boundary of the Town Moor, Nun's Moor and Castle Leazes. This particular stone marked the southeast corner of the Town Moor, and a plaque on it says that it has been put here to remind the citizens of Newcastle upon Tyne of the extent of their heritage. The Town Moor was established in the thirteenth century when the Newcastle burgesses, later known as Freemen, agreed to look after the land and pay rent to King John in 1213. The famous Hoppings fair takes place each year in June. On the other side of the road, beyond the site of the Great North Museum, was a field known as the Bull's Park where the corporation's prize bull was kept for many years. The name of the field remained long after this practice stopped.

The Wren Stone, Civic Centre

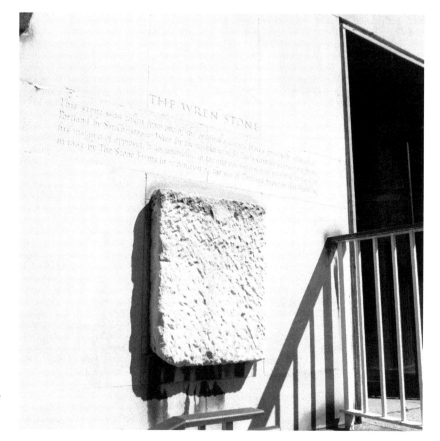

A stone that should have formed part of St Paul's Cathedral in London was incorporated into the wall of the Civic Centre beside the main entrance.

I worked in the Civic Centre for over four years and walked past this stone close to the main entrance every day without once noticing it. I could be forgiven as it is a perfect match to the smooth Portland Stone that the main tower is built of, and the engraving on the wall is not highlighted in any way. It is known as the Wren Stone, named after the builder of St Paul's Cathedral in London as it is said to come from the same quarry used by Sir Christopher Wren and was personally selected by him and actually has his mark upon the stone, presumably for use in building the London landmark between 1675 and 1710. For some reason he did not use the stone, and when stone was being sourced for the Civic Centre it was put to one side and donated to the city in 1965 by the owners of the quarry to be incorporated into the new civic building as a curiosity. The Civic Centre was designed by the then city architect George Kenyon and was opened in 1968 by Olav V of Norway. Every year a Christmas tree is sent from Norway to stand outside the building. The most notable visitor to the Civic Centre was President Jimmy Carter in 1977 when he said the famous words 'Howay the Lads'.

Lord Armstrong Statue, Claremont Road

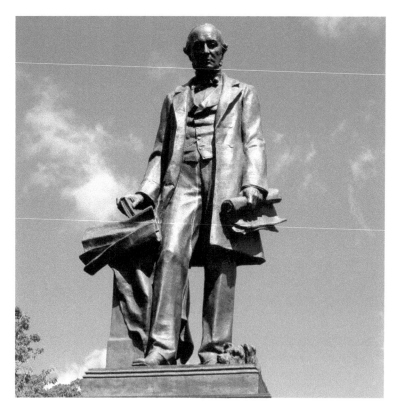

The great industrialist who lived at Cragside in Northumberland and who donated Jesmond Dene to the city stands proudly outside the Great North Museum. He helped to finance it when it was known as the Hancock.

Lord Armstrong stands proudly looking out towards Newcastle in front of the former Hancock Museum, which he helped to fund; it is now part of the Great North Museum. William Armstrong was born in 1810 in Shieldfield and trained as a lawyer. He practiced for a number of years while he developed his interest in engineering, and had a number of friends in industry such as Henry Watson, who allowed him access to their workshops to carry out experiments on some of his inventions. His first success was in using water power, and he invented a hydraulic crane, which led to him leaving his law practice to form a new crane building company. He later set his mind on improving weapons and invented a lightweight and very accurate breach loading gun on a carriage generally regarded as a 15-pounder, which changed the face of war. To build his weapons and warships he developed a massive factory in Elswick and even designed the Swing Bridge using hydraulic power to get access to his new factories. The two brass reliefs below his statue show Armstrong's Swing Bridge and guns being loaded onto a ship using a hydraulic crane. He died in 1900 aged ninety, and is buried in Rothbury, not far from his home in Cragside, which was the first house in the world to be lit using hydro electricity. This statue of Lord Armstrong by W. Hamo Thornycroft was erected in 1905.

Victoria Tunnel, Claremont Road

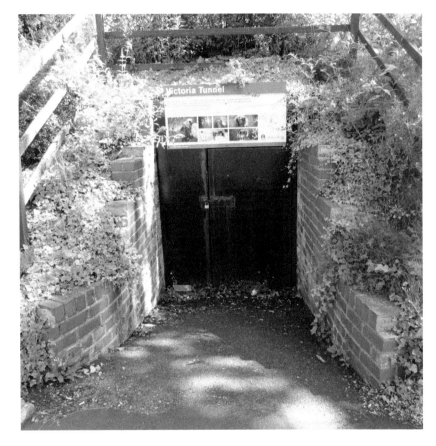

This is one of seven entrances to the Victoria Tunnel that runs under the city from Spital Tongues to the Ouseburn. It was used as an air raid shelter during the Second World War.

This is one of the seven entrances to Victoria Tunnel, which was used as an air raid shelter during the Second World War. Victoria Tunnel is 2.5 miles long and runs from Spital Tongues, north of Newcastle, under the city centre reaching a maximum depth of 26 metres, and emerges near the River Tyne at the Ouseburn. The tunnel was originally built by the owners of Spital Tongues colliery to transport coal underground to ships on the river after they were refused permission to build an overland wagonway. It took three years to build between 1839 and 1842, and was only used for eighteen years. It stopped being used for coal transport in 1860. In 1939 it was decided to convert parts of the tunnel into air raid shelters and to do this a new concrete floor was laid with drainage, electric lighting was provided with back up hurricane lamps. Chemical toilets (or glorified buckets) were provided behind screens, benches to seat 9,000 people and 500 bunks were built to allow workers and residents to shelter from enemy bombing raids. Other entrances were at Claremont Road, St Thomas' churchyard, Ridley Place, Stoddard Street, Crawhall Road and Ouse Street.

Newcastle University Sculptures

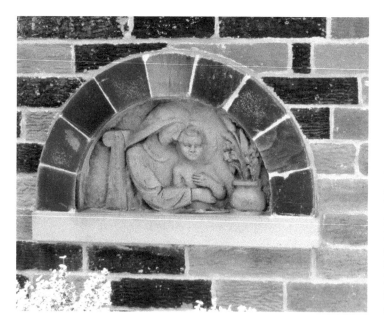

Built into a wall of one of the university buildings to the rear of the Great North Museum is a sculpture from the medieval St Mary Magdalene Hospital that stood on a nearby site.

Hidden behind various university buildings and close to the rear entrance of the Great North Museum is a piece of sculpture taken from an ancient building, thought to be part of the St Mary Magdalene Hospital. The stone image, now mounted into a wall, is thought to represent St Mary Magdalene caring for a young child. Originally sited where the present St Thomas' church is on Barras Bridge, St Mary's hospital was deliberately built outside the town walls, close to the main road north, as it was thought to a be leper hospital originally. There was also a similar building also described as a leper hospital close to Tynemouth and the remains of St Leonard's Hospital are now in Northumberland Park. A new hospital called Mary Magdalene was built in Spital Tongues and later became the Hunter Hospital. A number of sheltered houses are still called after St Mary Magdalene. Land owned by the hospital was developed as St Thomas' Street and Crescent. The site of the Hancock Museum was originally occupied by an ancient chapel to St James that was thought to be linked to the hospital. This may possibly have resulted in the naming of St James' Terrace, which in turn led to the nearby football ground being called St James' Park.

The Edward VII statue is situated in a Tudor style building above the arches, leading into the quadrangle to the north of the Students Union and Northern Stage within Newcastle University campus. He was the monarch until 1910, and the complex of buildings formed part of the King Edward VII School of Art – now known as the School of Fine Art. The buildings were designed by W. H. Knowles and opened in 1911; a plaque on the wall inside the arches confirms this and other buildings, including the Hatton Art Gallery, were completed in 1913. The arches had gates in them with a porters lodge on the north

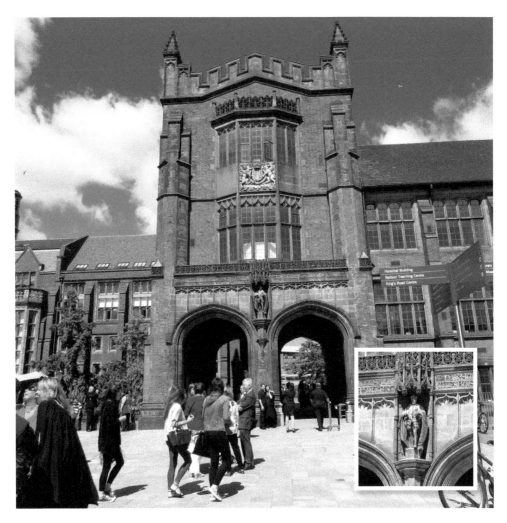

A statue of Edward VII is incorporated into the arches beside the Hatton Gallery. The buildings formed part of the King Edward VII School of Art.

side. During the First World War, the buildings were used as a military hospital and the porters lodge was the guardhouse. Edward VII had visited Newcastle on a number of occasions and, in 1906, he opened the Royal Victoria Hospital, Armstrong College and the railway bridge (the King Edward Bridge named after him) all on the same day. Newcastle University started life as an outpost of Durham University and was at first referred to as Kings College after George VI opened the medical school in 1938.

A number of large sculptured heads have recently been installed as part of a major hard landscaping scheme to form a new public space, or student forum, within the centre of the Newcastle University campus. The artworks are collectively known as 'Generation' or unofficially as 'Quad Heads' as they adjoin the quadrangle, and they were sculpted by a former Newcastle fine art graduate Joe Hillier. The area lies immediately to the west of the Arches and once was the site of the Museum of Antiquities which occupied the site

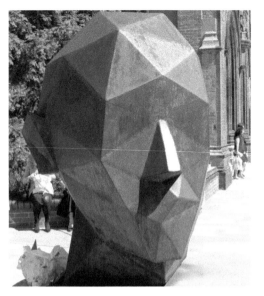

Above left: To the west of the Hatton Gallery a new open space has recently been created and is the home of a number of 'head' sculptures collectively called the 'Quad Heads'.

Above *right*: The Quadrangle behind forms a war memorial to the dead from the university.

from 1959 to 2008. The buildings were originally built as a Coke testing station in 1949 as part of the Department of Chemistry, however, they were not considered to be of high architectural significance and they also interrupted views of the Armstrong Building and Jubilee Exhibition Tower from the south.

The quadrangle behind the arches is laid out as an attractive landscaped garden that forms an alternative type of war memorial. A small brass disc attached to a wall around a flower bed describes how the garden quadrangle was laid out in 1949 by J. S. Knowles in memory of all the members of the Newcastle Divisions of the University of Durham who lost their lives during both World Wars. The buildings overlooking the quadrangle were used as a military hospital during the First World War, including the newly built building now known as the Hatton Gallery. It was named after Professor R. G. Hatton, the first professor of fine art from 1921–26. The School of Fine Art was a direct successor to the Newcastle School of Art and Design established in Newcastle in 1844 and having William Bell Scott (the artist of the famous wall murals at Wallington Hall) as its Master from 1844–64. Other buildings fronting onto the east side of the garden include the School of Agriculture, built in 1913 and now the school of Architecture, Landscaping and Planning, and the old library building. On the north side is the more modern Percy Building, dating from 1958 and named after the first rector of Kings College, Lord Eustace Percy. Armstrong Building occupies the west side and was built in stages between 1887, when Lord Armstrong laid the foundation stone, and 1904. The Jubilee Tower was built to commemorate Queen Victoria's fifty years on the throne and was designed by R. J. Johnson. It was built using funds from a major Jubilee Exhibition held on the Town Moor. The main entrance was designed by W. H. Knowles and was officially opened by Edward VII in 1906.

Second World War Lookout Shelter, Percy Street

A very rare relic from the Second World War is situated to the rear of the Bruce Buildings and has only recently been rediscovered and identified.

To the rear of Percy Street is a fire wardens look out shelter – a very rare survivor of the Second World War. The only other known surviving similar structure overlooks North Shields ferry landing. It is built above the rear yard of what was the Newcastle Breweries head office on Percy Street. The structure is still intact with a reinforced cylindrical chamber with lookout slits with an access ladder behind heavy steel doors. Fire wardens would stand inside and look out during air raids to observe bomb damage, especially from incendiaries, and were able to coordinate fire fighters when buildings caught fire. The structures had been extensively tested during the design phase and could withstand such eventualities as buildings collapsing on it. The building fronting onto Percy Street was known as the Bruce Building, named after Alexander Bruce who was one of the main directors of Newcastle Breweries at the time the building was built in 1896. It was designed by Joseph Oswald. The building contains some fine Bermantoft tiles, mahogany doors and stained-glass windows, which have been retained and incorporated into the recently refurbished building that now forms part of the Newcastle University complex.

William Bell Scott Studio, St Thomas' Crescent

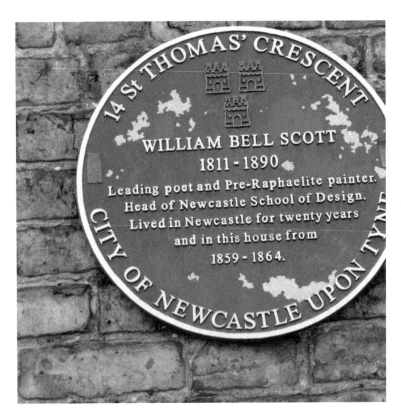

The artist responsible for the famous Wallington Murals lived here when he was Master of the Newcastle School of Art and Design and built a studio in the backyard, which is now used as a meeting room.

The Newcastle School of Art and Design was established in Newcastle in 1844, and William Bell Scott (1811–90), best known as the artist of the famous wall murals at Wallington Hall, was its Master from 1844–64. The original building was built as the result of the generosity of a number of patrons of the arts who supported a large number of talented local artists such as Miles Richardson and John Carmichael. It was built on Blackett Street where the present Eldon Square shopping centre now stands opposite Eldon Square. Unfortunately it was not a success and the building was re-let for a number of commercial ventures before being demolished in the 1960s. William Bell Scott, who originally came from Scotland, lived in two properties on St Thomas' Crescent, and there is a plaque recording this outside No. 14 where he lived from 1858–64. His artist studio still survives in the backyard and is currently still in use as meeting rooms for the local community. William Bell Scott was a leading Pre-Raphaelite painter and poet and had an international reputation at the time. He was a great friend of many Pre-Raphaelite painters including Gabriel Rossetti, and his studio is often referred to as the Rossetti studio. A number of famous local artists trained at the School of Art including Ralph Hedley, Henry Hetherington Emerson, John Surtees and Charles Napier Hemy.

Royal Victoria Infirmary, Queen Victoria Statue

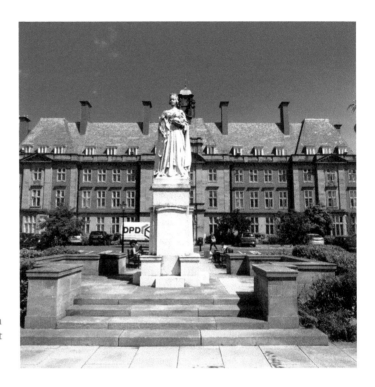

This rare statue of a young Queen Victoria in white stone is situated at the west end of the RVI outside Peacock Hall.

The Statue of Queen Victoria by sculptor George Frampton at the Royal Victoria Hospital was unveiled by her son Edward VII on 11 July 1906. It is unusual for two reasons: firstly it is of the young Queen Victoria in a standing position at the time she became Queen in 1837, and secondly it is white in colour. Two other better known local statues at St Nicholas' Cathedral and at Tynemouth are almost black in colour and of Queen Victoria in old age sitting on a throne not looking very amused. The statue is positioned in a prominent site outside the impressive Peacock Hall, which was one of the main entrances to the RVI at one time. It has recently been renovated together with the impressive conservatory and St Luke's chapel to form an educational and administrative centre. The RVI replaced the former Newcastle Infirmary that occupied a site on Forth Banks to the west of Newcastle Central station since 1752. The RVI when built was considered to be the state of the art in hospital design. Work started on the 10-acre site in 1900 when land was given on Castle Leazes by Newcastle Corporation after £100,000 had been raised by a fund set up to commemorate the Diamond Jubilee of Queen Victoria. A further £100,000 was given in donations from Mr John Hall and Mr and Mrs W. A. Watson Armstrong. Major improvements have recently been carried out to the RVI, with a lot of the original wards being demolished and replaced by modern buildings to provide up to date facilities for the present residents of Newcastle.

Central Arcade Tiles, Grainger Street

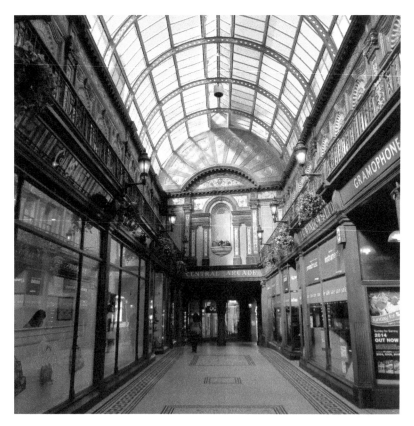

The Bermontoft tiles in the Central Arcade give the shopping arcade a unique character in Newcastle. They date from 1906 when the interior of the building was renovated following a fire.

The Central Arcade is unique in Newcastle as it is the only Edwardian purpose-built shopping arcade that retains many of its original features, not least the magnificent Bermontoft tiles. If you look closely you will find some tiles dated 1906 that were installed when the arcade was refurbished by the architects Joseph Oswald & Sons following a major fire in 1901. The original triangular-shaped building was built by Richard Grainger in 1837 and was designed by Walker and Wardle. Grainger wanted it to be the town's corn exchange, but the corporation had other ideas; Grainger opened it as a newsroom and exhibition area. It was so popular with the growing number of wealthy residents that it soon had 1,600 members who paid one guinea a year to be a member. It was later refurbished to include a reading room, art gallery and concert hall holding 1,000 people; later it became a Vaudeville theatre in 1897. On the south side facing Market Street, a fifty-bedroom hotel was built called the Central Exchange Hotel. Windows music and instrument shop has been in the arcade since it became a shopping centre, and some curious signs still remain from earlier traders. One of these refers to John Hamilton, bootmaker, who advertises the added attraction of a discrete 'ladies fitting room'.

Garibaldi Plaque, Nelson Street

Giuseppe Garibaldi, the Italian national hero and freedom fighter, visited a bookshop here in 1854. He is probably better known in this country for having a biscuit named after him.

At the Grainger Street end of the Grainger Market on Nelson Street is a plaque above the corner shop stating that it used to be bookshop that was visited by international celebrities. Three are listed: Giuseppe Garibaldi (Italian national hero and freedom fighter) in 1854; Louis Kossuth (Hungarian lawyer, journalist, politician and Freedom Fighter) in 1856; and William Lloyd Garrison (American anti-slavery campaigner, journalist and social reformer) in 1876. The plaque was erected by Joseph Cowen, founder of the *Evening Chronicle*, who himself was considered to be a radical. Garibaldi also visited Tynemouth in 1854, and there

Charles Dickens Plaque, Nelson Street

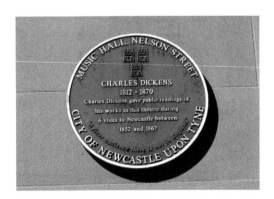

Charles Dickens was a regular visitor to Newcastle, performing readings from his books at the music hall on this site, now replaced by Eldon Square Shopping Centre. He also had a mistress called Nelly Ternan who lived in Newcastle.

is a plaque on the wall of Kings Priory School to record this. At the time, the building was part of Tynemouth House, owned by George Crawshay who was an iron manufacturer and friend of Joseph Cowen. It is also said that the famous garibaldi biscuit was first seen at Tynemouth. The story goes that he was offered an Eccles cake during his visit. He then put it on his chair and accidentally sat on it, producing the first Garibaldi biscuit. Nelson Street was named after Admiral Nelson. At the end of the street the vista was closed admirably by the Lord Collingwood pub, built in 1837 by Wardle and Walker to replace the earlier Lord Collingwood pub situated beside the original Theatre Royal on Mosley Street. In recent years, the former pub has been used as an amusement centre. Lord Collingwood was the actual victor of the Battle of Trafalgar, Admiral Cuthbert Collingwood from Newcastle who took over from Nelson after he died during the sea battle.

Nos 10–12 Nelson Street were built in 1838 as a music hall and lecture room, which later became the Gaiety Cinema from 1911–49. It still has a sign for music hall on the north side, which is now part of Eldon Square shopping centre. There is also a plaque to say that Charles Dickens (1812–70) visited the music hall on six occasions between 1852 and 1867. On the plaque he is quoted as saying the following in respect of the people of Newcastle: 'A finer audience there is not to be found in England.' He gave a reading here in 1861 of *David Copperfield* and other books. He was very popular in his day and on one occasion 600 people each paid 12s and 6d, squeezing into a room that held 300. Another reason for his many visits may have been that his long-term mistress, Nelly Ternan, lived in Newcastle on Pilgrim Street. Her father was at one time the manager of the Theatre Royal. Nelly has recently been portrayed as *The Invisible Woman* in a film based on her relationship with Charles Dickens. Dickens tried to keep Nelly a secret from his adoring public, and when Charles Dickens was feted as a hero by helping fellow passengers injured in a train crash no mention was made in the numerous newspaper reports that he was actually travelling with Nelly. Many were critical of how Charles Dickens treated his wife during the affair, but he was such an influential figure at the time that this was kept largely out of the public domain.

Penny Bazzar, Grainger Market

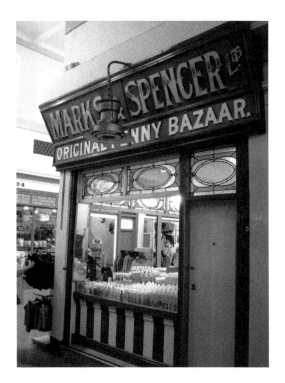

The oldest Marks & Spencer shop in the world is found in the Grainger Market. It dates from 1895 and was not the original Marks & Spencer Penny Bazaar, as that was opened in Leeds but closed some years ago.

The original Marks & Spencer Penny Bazaar, dated 1895, is now the oldest Marks & Spencer shop in the country; the previous oldest bazaar, which was in Leeds, no longer exists. Michael Marks was a refugee from Poland who came to Leeds and met Isaac Dewhurst, who owned a warehouse. Marks opened his first Penny Bazaar stall in Kirkgate Market in Leeds in 1884. He later went into partnership with Thomas Spencer, who worked for Dewhurst as an accountant. They set up penny Bazaars with free admission all over the north and then opened high street stores based on five key principles: quality, value, service, innovation and trust. The first stall in Leeds no longer exists, but a Marks & Spencer heritage and coffee shop was opened in Kirkgate Market in 2013. Everything in the bazaar was originally only one penny to buy and entry into the shop was free. The lamps are the original gas mantles, now converted to electricity; they still have their original chains attached. The Grainger Market was built by Richard Grainger in 1835 to replace the earlier Flesh Market that was situated on the present Grey Street and took only eighteen months to build. When it opened there was a public dinner for 2,000 male guests on Thursday 22 October 1835; a further 300 ladies were seated on a specially erected balcony to witness the celebrations. At first it was mainly occupied by butchers, and originally there were 180 butchers with some fruit and vegetable traders. The cellars underneath were used to store the meat as it was cooler.

John Clayton Plaque, Clayton Street

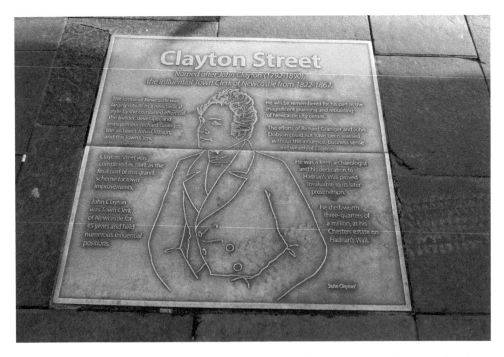

This floor plaque can be found in Clayton Street close to the Grainger Market around midway along the market frontage close to one of the entrances. John Clayton was the town clerk of Newcastle who worked closely with Richard Grainger in the 1830s.

Clayton Street in Newcastle, completed in 1841, is named after John Clayton (1792–1890) who was the town clerk for Newcastle from 1822–67. He took over from his father Nathaniel Clayton who was town Clerk for the previous thirty-seven years from 1785. He worked closely with Richard Grainger and John Dobson on the redevelopment of the centre of Newcastle in the 1830s and 1840s to produce the magnificent streets of Grey Street, Grainger Street and Clayton Street – now referred to as Graingertown. He was a qualified solicitor and lived in the family town house in Fenkle Street with his brother and legal partner Matthew. He was a very keen antiquarian and a great champion of Hadrian's Wall; many believe he has done more than anyone else to preserve the ancient monument. He set about buying the land it was situated on in central Northumberland and then employed a workforce to excavate and consolidate many forts and large stretches of wall. Much of Hadrian's Wall that can be seen today, rising and falling over the dramatic landscape of the Whin Sill in the central sector around Housesteads Roman fort, is directly linked to Clayton's endeavours and enthusiasm. The famous picture of Hadrian's Wall at Wallington by William Bell Scott is said to feature John Clayton, possibly as the centurion overseeing the building of the monument.

White Cross Plaque, Newgate Street

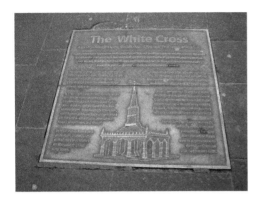

Above: The White Cross was a prominent local landmark situated on Newgate Street from before 1410 until 1808 and marked the entrance to the main markets of Newcastle.

Right: The pavement plaque recording the lost White Cross is located opposite the large green glass sculpture known as *Ellipsis Eclipses* in Newgate Street.

The plaque is positioned close to where a historic White Cross stood from before 1410 until 1808. It marked the entrance to the main markets in Newcastle, which included the Bigg Market, Groat Market, Flesh Market, Poultry Market and Iron Market; some of these names still live on today. The area close to where the cross stood in more recent years developed into the site of the original Green Market, which was eventually housed in premises on the corner of Newgate Street and Clayton Street before Eldon Square was developed. The cross itself changed in appearance over time, starting as a simple cross, and was later replaced in 1783 by an ornate structure, providing a covered shelter with an ornate spire and a good clock, designed by local architect David Stephenson as illustrated on the plaque. This structure was taken down in 1808 and re-erected at the Flesh Market close to Mosley Street on the site of the present Grey Street. It was then lost to further developments when Richard Grainger demolished the Flesh Market, replaced it with the Grainger Market and built Grey Street on the site of the original market. In 1701, John Fenwick, a local coal owner from Rock, was hanged from a white thorn tree after murdering Ferdinando Foster MP for Northumberland. They had an argument and Fenwick stabbed him in the back. He ran away but was caught a week later, and was then tried, convicted and condemned to death.

Newgate Street Plaque

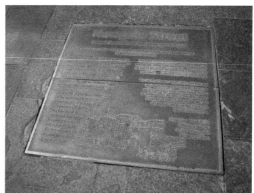

Left: The Newgate Street plaque is located in the pavement opposite the 'Gate'. The former Art Deco designed Co-op department store is seen in the background.

Above: Another pavement-mounted brass plaque records the history of the street named after the nearby New Gate which was part of the Town Walls.

A plaque on the pavement opposite The Gate is entitled Newgate Street and includes a picture of the New Gate. Newgate Street was named after the 'New Gate' that was built as part of the town walls around 1300 and was demolished in 1823. This was one of the strongest gates as it faced north and had three storeys, with a barbican or second gate in front for extra protection. From 1399–1822, the gate doubled up as Newgate Gaol (prisoners from Northumberland were held in the castle keep). A vaulted room stood on each floor, and the walls included many rooms that were used as cells for prisoners. They were not always secure and a number of escapes were recorded over time. Howard, the inspector of prisons, found Newgate to be warm, clean and well ventilated, unlike the castle. The condemned cell was said to be whitewashed to give the unfortunate prisoner a last comfort before he took his last trip along Gallowgate, which was named after the gate or street to the gallows situated not far outside the New Gate on the Town Moor on what is now Barrack Road. Public hangings were a very popular event; crowds of locals would gather to watch the grisly event. The last person to be hung in public was Mark Sherwood, who murdered his wife and met his maker in 1844. By that time he would have been held in the new gaol or model prison designed by John Dobson and built at Carliol Square in 1822 at the bottom of Worswick Street. After that date all hangings took place within the prison itself.

Charles Avison Plaque, St Andrew's Churchyard

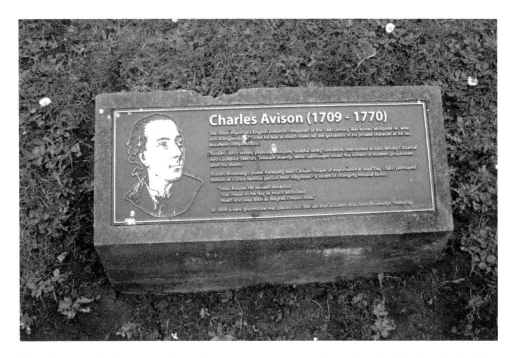

The plaque to the famous eighteenth-century composer is located on the left-hand side of the path to the church, opposite the chancel, from the Newgate Street entrance.

Charles Avison (1709–70) was buried in St Andrew's churchyard with his wife, son and grandson and was said to be the most important concerto composer in England in the eighteenth century. The famous musician and composer from Newcastle was born close to the New Gate to a father who played in the town band. He went to London to learn his trade as a fiddle player and is said to have employed Handel at one time. He decided to come back to Newcastle to live and played the organ at St Nicholas' and St John's. He also put on his own concerts at the Assembly Rooms, which were very popular at the time. He has been called 'an eighteenth-century Andrew Lloyd Webber' as his music was contemporary and popular. Newcastle became the greatest provincial music venue after London, and the popularity of his music upset London musicians including Vivaldi and Handel. His popularity did not last as musical tastes changed over time; this was recorded by Robert Browning in 1887 in a poem called 'Parleying with Certain People of Importance in their Day'. He said that Avison's music was once as popular as the then current composer Wagner. Very few people in Newcastle today have heard of Charles Avison, but Wagner is still considered to be one of the greatest composers of all time.

Heroic Figure, Former GEC Building, Gallowgate

The former GEC building, close to Percy Street is now called Magnet Court and has some very impressive Art Deco features including a number of heroic figures of men at work in the electricity industry.

These 'heroic' figures represent the power of electricity in this Art Deco style interwar building dating from 1936. The building on the north side of Gallowgate, close to Percy Street, was built for the former General Electric Co. by Cackett, Burns, Dick & Mackellar. These figures, cast in metal and designed by Halliday & Agate, have been built into the central section of the main façade of the building and show men at work in the electricity industry, similar to those at Battersea Power Station in London, designed by Giles Gilbert Scott. The building itself is steel framed, with brick and Portland Stone used as cladding, and it included over 100 windows. The building, now referred to as Magnet and Andrews Houses or Magnet Court, was converted to student flats in 2002, incorporating an extra storey at roof level as well as extensions to the rear after being threatened with demolition. The buildings on the opposite side of Gallowgate were built onto the town walls themselves. The town walls were built along the north side of St Andrew's church around 1300, and the land between was used as a cemetery. When the walls were abandoned and the Newgate was demolished in 1824, builders took advantage of the existing wall and used it as the rear wall to the new buildings fronting Gallowgate. There is a plaque on the former town wall fronting onto Newgate Street at the rear of the first building on Gallowgate.

Chinese Arch, Stowell Street

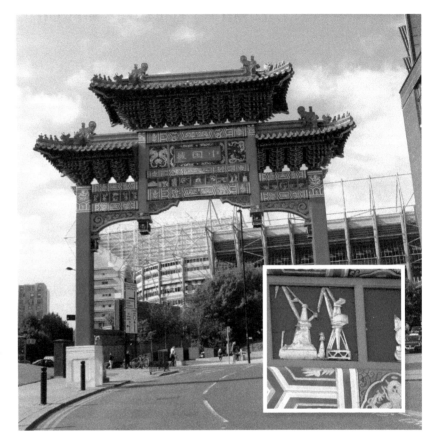

This impressive entrance feature to Newcastle's Chinatown was built by Chinese craftsmen and incorporates a number of local scenes into the design.

The Chinese Arch was erected in 2005 and was designed by Yonglai Zhan for the Chinese community. It was commissioned by the Grainger Town Urban Regeneration Programme and is sited on the edge of the Chinatown area. The arch was built by twelve craftsmen from China working for the Changshu Classical Gardens Architectural Engineering Co. It is 11 metres (33 feet) high and 9 metres (27 feet) wide. It is made of wood and stone and is decorated with glazed tiles and paintings. Seven panels at the top of the arch show scenes from the north-east and Tyneside making the arch unique to the area. Local scenes include Emperor Hadrian's head, Stephenson's *Rocket*, Grey's Monument, shipyard cranes from Wallsend, Bamburgh Castle and bridges over the Tyne. The Fu Lions bring good luck and are mythical protectors of the town or building; their origins go back to 206 BC and are usually found outside important Chinese buildings all over the world. The female is on the left and the male on the right facing St James' Park; the male has his foot on a ball (in honour of Alan Shearer) and he protects the outside areas, and the female has her foot on a lion cub and protects the inside of buildings. The pearl inside the lion's mouth can

Sir Bobby Robson Memorial Garden, Gallowgate

Opposite the Chinese Arch and below St James' Park is a memorial garden to one of Newcastle United's best loved managers.

be moved by hand but cannot be taken out! The original Chinese residents were thought to be stokers from ships who settled in the town and established restaurants. Chinatown occupies Stowell Street, which was originally built in 1824 as a residential street and named after Lord Stowell. William Scott, who became Lord Stowell, was the brother of John Scott (Lord Eldon who eloped with Bessie Surtees and who Eldon Square is named after). Lord Stowell was a Judge of Maritime Law in the Admiralty. Stowell was the name of his Gloucestershire estate where he lived later in life.

The Sir Bobby Robson Memorial Garden was opened in 2011 opposite the Chinese Arch and is directly overlooked by St James' Park, the home of Newcastle United. The memorial sculpture was made by Graeme Mitcheson and was commissioned by Newcastle City Council. Sir Bobby is best remembered in Newcastle for the charity in his name, which continues to raise money to fight cancer. The Pocket Park has five carved stones erected on the west side, each including some aspect of Bobby Robson's life in football. One shows an old style football boot and leather ball together with a miner's lamp, pit-head wheel and tools to recall that he started life as the son of a miner in Langley Park, Durham. Another stone features a profile of Sir Bobby with a football pitch behind. Others record all the football clubs he has played for and managed including Fulham, West Bromwich Ipswich, PSV Eindhoven, Sporting Lisbon, Porto, Barcelona and Newcastle. All the stones include the names of some of the famous footballers he managed including; Christiano Ronaldo, Popescu, Blanc, Guardiola, Ruud Van Nistelrooy, Figo, Alan Shearer, Speed, Given and Gascoigne. Another stone mentions his England career of twenty games and four goals as a player as well as managing England from 1982–90. He led England to the semi-final of the World Cup in 1990 and the quarter finals in 1986.

Wor Jackie Sculpture, St James' Park

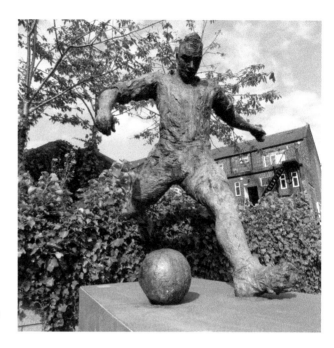

Newcastle United's hero of the 1950s, Jackie Milburn, was a member of the team that won the FA Cup three times between 1952 and 1955 and scored the quickest ever goal in a cup final.

This sculpture of 'Wor Jackie' by Susanna Robinson was erected outside St James' Park in 1991. It was erected in honour of John Edward Thompson Milburn (1924–88), footballer and gentleman. Jackie Milburn was one of Newcastle United's greatest players and until 2006 was the club's record goal scorer with 201 goals - a record now held by Alan Shearer with 206 goals. Jackie was born in Ashington in Northumberland and is a second cousin of Jack and Bobby Charlton who won the 1966 World Cup with England and also came from the same coal mining town. He played for Newcastle United between 1943 and 1957. He was a member of the famous teams that won the FA Cup three times between 1951 and 1955. He also scored the quickest ever goal in a cup final in 1955 scoring in the first forty-five seconds of the match against Manchester City when the team won 1-0 - the record stood until 1997. He also played for England fifteen times scoring five goals. He started life working in the pit at Ashington and used to travel to Newcastle on the same bus as the fans. He did not make a fortune from football, unlike current players, and lived modestly in the region for the rest of his life.

Joe Harvey (1918–89) was a legendary player and manager for Newcastle United. He is still the last Newcastle manager to win a major trophy for the club when the team won the European Inter Cities Fairs Cup in 1969. He also won the FA Cup as a player with Newcastle in 1951 and 1952, and as a coach in 1955. In 1974 he was manager when Newcastle lost in the cup final 3-0 to a Kevin Keegan-inspired Liverpool. He played from 1945 to 1953 for Newcastle after previously playing one game for Bournemouth. His managerial career

Joe Harvey Plaque, St James' Park

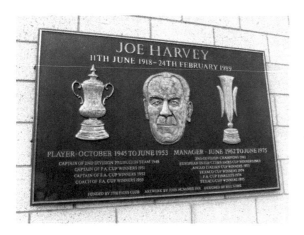

Joe Harvey was a player and manager for Newcastle United and still has the honour of being the manager when the team last won a trophy. The plaque faces Strawberry place not far from Wor Jackie's statue.

started at Barrow, then at Workington, before taking over at Newcastle. He even came back to manage Newcastle for a few weeks in August 1980 between the sacking of Bill McGarry and the appointment of Arthur Cox. As captain of Newcastle he was also in the team promoted from the Second Division in 1948. Joe was a no-nonsense defender and a born leader during his playing days, and was considered to be a hardworking, blunt old-style manager who set a high standard both on and off the pitch. Although he had a fair amount of success as a player and manager, he was unfortunate to have the dubious honour of being in charge of the team dumped out of the FA Cup by Hereford in 1972 and then the following week win 2-0 away at Manchester United in a team including George Best, Dennis Law and Bobby Charlton. The plaque was paid for by a group of fans who formed the Fairs Club to celebrate the Fairs Cup win; the artwork was by John McNamee Jnr and the plaque was designed by Bill Gibbs.

Town Walls, Gallowgate

Newcastle's town walls were built over a number of years with the main sections built around 1265 to 1313; other alterations took place over the years. The section between Gallowgate and Westgate Road is the most striking stretch of remaining walls in Newcastle. The walls were over 2 miles long and the wall itself was between 7 and 10 feet wide. The height varied according to local circumstances from 14 feet to 23 feet. There was a parapet on top of the wall up to 5.5 feet high, with splayed openings (embrasures) in it. There were nineteen towers, thirty turrets, seven gates and three posterns or side gates, together with

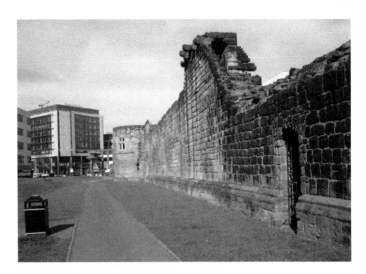

This long stretch of the town walls extends from the Chinese Arch on Stowell Street towards Bath Lane. The structure on top of the wall is a turret with Morden Tower beyond.

seventeen water gates on the Quayside leading to the riverside for merchants to reach their ships. Two gates had barbicans – the Westgate and the Newgate. Behind the wall was a roadway (intramural road) to allow troops to move quickly around the walls. Outside was a major defensive ditch, known as the Kings Dyke, which was 37 feet wide and 15 feet deep, set 31 feet from the wall to prevent the enemy from using a battering ram. Turrets were set between towers and were mainly intended as lookouts and shelters for soldiers in bad weather. They had a single loophole for archers to shoot through, with a recess at the back to allow him to draw the bow; this may well have led to the saying 'give him elbow room'. The turret was flush with the main wall at the front but projected backwards on corbels. An external staircase gave access to the roof, which was battlemented with machicolations (gaps in a projecting parapet, to drop objects through onto the enemy below) to the front. The turret seen here lies between the Herber and the Morden Tower shown in the background.

The Gallowgate lead works occupied the site for 150 years from 1783 to 1933. Lead shot was made by dropping molten lead 200 feet down a shaft into water troughs. The shaft is marked beside the information board together with three mill stones that were used in a different process to make white lead. The lead works were owned by the Locke Blackett Co., and other lead works existed in Ouseburn, Walker and Elswick. Elswick was famous for its landmark shot tower, which produced lead shot for shot guns and for the artillery. Here at Gallowgate, a 200-foot pit was constructed that molten lead was dropped down after passing through a sieve where it landed in a pool of water to form perfect spherical lead shot. After around 2 tons of lead had been sent down, a man was then lowered down the pit on a rope to collect the lead shot and bring it to the surface. The white lead was made by placing sheets of lead in layers, separated by earthenware pots, then acetic acid was poured on top to produce a blue paste that when dried formed white lead pigments for use in the paint industry. The buildings of the lead works occupied a large site outside the town walls, and the walls themselves were incorporated into some of their building, which directly led to their preservation. Today, the area covered by the lead works forms an open space with a replica of the town wall ditch incorporated into it. The ditch is not as big as the original ditch, which was 37 feet wide and 15 feet deep.

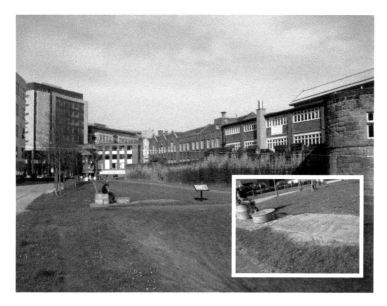

Left: The West Wall ditch is seen either side of the site of a notice board relating to the former lead works on the site. *Inset*: The site of the 200-foot deep lead shot shaft is indicated on the surface beside two millstones that were used to produce white lead in the leadworks.

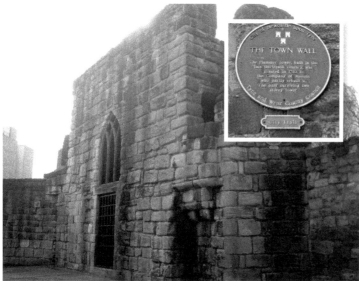

Left: The inward side of the Herber Tower is still largely intact and had been used by the Company of Armourers, Curriers and Felt-makers from 1620. *Inset*: A number of blue plaques can be found at different points around the town walls to identify the wall and individual towers.

At one time the walls were so impressive that many considered them the best in England, and only a few towns in Europe had more striking defences than Newcastle. Today, there are more walls preserved in Newcastle than in most other English towns, with the exception of Chester, York, Southampton and Chichester. As they were built, changes took place to include the township of Pandon as well as to include the Carmelite friary west of the castle. The main reason for building the walls was because of the threat from the Scots, who had attacked the town on a number of previous occasions. At one time Newcastle was considered to be part of Scotland and was even promoted as a potential capital of Scotland. It is also said that St Andrew's church was built by a Scottish King when Newcastle was occupied by the Scots in the twelfth century. Herber Tower is almost

intact and had a large upper window inserted by the Company of Armourers, Curriers and Felt-makers in 1770, who occupied the tower from 1620; in the nineteenth century it was used as a blacksmiths shop. Most of the towers were of a similar design, with a rectangle on the inside and D-shape or semi-circle on the outside. The rounded tower was much stronger than the earlier medieval rectangular tower as it had no blind spots and was harder to undermine. The Herber Tower is the most perfectly preserved and is typical of its type. It is one storey in height, with a stone vault to carry the roof. It has three large cross loopholes for archers – one facing outward and two covering the curtain walls either side. The tower has large stone corbels, which were intended to carry wooden hoardings that were erected at a time of war. They projected over the battlements and had windows to shoot through. The roof was reached by an external staircase.

Opposite the Herber Tower a hospital was built as a fever or typhus hospital (house of recovery) in 1804 for the 'infected poor' and was sited not far from the earlier lunatic asylum of 1767. It was an awful place that was just like a prison, with pauper lunatics chained to the walls in appalling conditions until 1824 when the Corporation took it over. The lunatic asylum was closed following the 1855 Lunacy Act that introduced better standards of care, and patients were transferred to new premises at St Nicholas' at Coxlodge. A new doorway was made in the town wall at the same time to give access to the hospital. The fever hospital was very busy dealing with typhus, cholera and smallpox and in 1855 they had 230 individual cases to deal with. Children were removed from families and parents were not allowed to visit; each patient was given a number and their progress could be followed by looking up the number in the local newspaper. At one time the hospital had an overflow temporary hospital built on the Town Moor. It remained as a hospital until 1888 when Walkergate Hospital was built. The building was recently used by the museum service. Before the building of the fever hospital the land was referred to as Warden's Close, and the warden, from Tynemouth priory, lived in Blackfriars and used the gate to access his garden and fishponds outside the wall; he also played bowls here. The bowling green laid down in 1827 survived till 1897 and was later used as a playground for the Rutherford school, which occupied a site on Bath Lane until the 1970s.

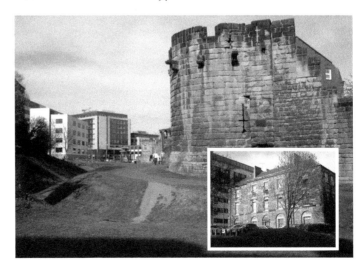

The outer side of the Herber Tower is seen on the right and over the ditch to the left is the edge of the former Fever Hospital, which is set back from Bath Lane.

Smiths Door, Blackfriars, Monk Street

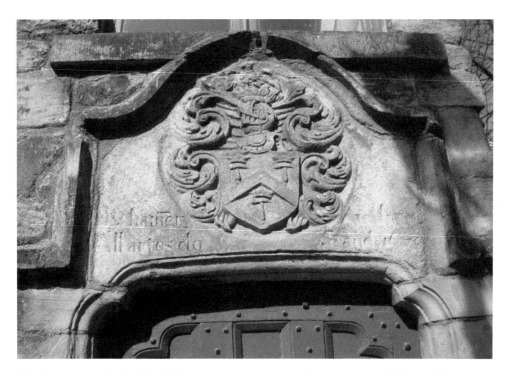

The doorway to the Smiths Hall includes the inscription 'By Hammer and Hand All Artes Do Stand 1679'.

This very old doorway is the entrance to the Smiths Hall on Monk Street. It was originally part of the friars warming house and dormitory. There is a coat of arms and an inscription over the door leading to the Smiths Hall that reads, *'By Hammer and Hand All Artes Do Stand 1679'*. This motto refers to the fact that without the skill of the blacksmiths, none of the other companies would exist as they all rely upon tools or implements made by them. The door and surrounds were brought from their original site in Low Friars in 1828 by the architect Thomas Oliver. There is also a plaque on the building stating that the building was repaired by the Company of Smiths in 1770. The Company of Smiths still meet in the hall and it still retains a lot of very old features, both in furniture and fittings. The middle section of this range of buildings, also fronting on to Monk Street, was formerly the refectory. It has impressive lancet windows and was taken over by the tanners and butchers and used as almshouses. The Cordwainers took over the former medieval kitchen, and it was reconstructed in Tudor style by John Wardle in 1844. The Cordwainers door, dated 1843, also has alms above it The Cordwainers originated in Cordoba in Spain and were fine leather shoe makers. There is also a plaque to say the Queen Mother opened the buildings again in 2000 after restoration.

Inner Courtyard, Blackfriars

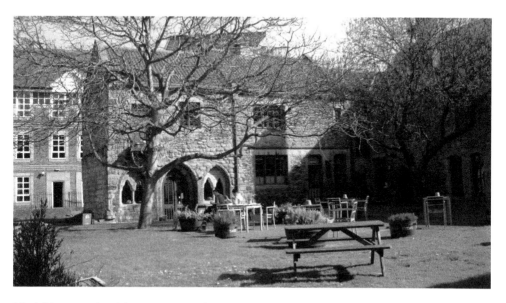

Blackfriars was the oldest Dominican friary in England. The cloister buildings were later used by a number of Newcastle companies or guilds.

Blackfriars is thought to be the oldest Dominican friary in England and one of the first in Europe. They were known as the black friars as they wore black robes and were also known as the shod friars as they wore shoes unlike other friars in town. The house was built some time before 1239, during the reign of Henry III, by Peter Scott, first mayor of Newcastle. Here in 1322, Edward II and his wife Isabella had a two-week holiday, and in 1334 Edward Baliol, King of Scotland, did homage to Edward III. It was the building that all Royal visitors to Newcastle would stop at during a visit to the town as there was no suitable accommodation in the castle. When the town walls were built nearby in 1265, they separated the friary from its orchards and gardens, but the friars did get permission to put in a gate in the walls and to build a swing bridge over the ditch. In 1539, Henry VIII closed all friaries and monasteries. Blackfriars closed after 300 years; the prior and twelve brethren were given redundancy and thrown out. The lead roof on the church and the bells were removed and sold for cash for the King. In 1543, the mayor of Newcastle bought the site, but the church was demolished and all the valuables were given to the king. The Corporation then leased the building in 1552 to nine of the towns craft companies, or guilds, who moved in and divided up the cloister buildings. The building ranges were divided into three company halls, with ground floor almshouses and a meeting hall above. During the 1900s, the buildings deteriorated and were used for a number of uses, and by the 1960s they were under threat of demolition. The site was saved in 1974 by local councils and national agencies and was opened in 1980 by the Queen Mother.

Westgate Road Artwork and Stoll Picture Theatre

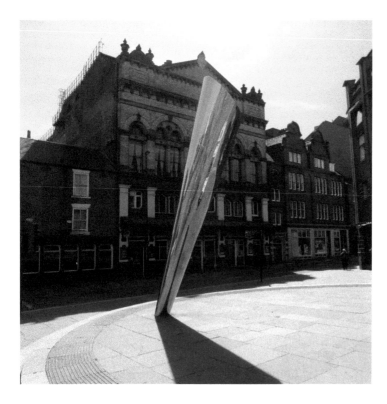

This artwork is a mirrored cone that reflects the ever-changing scene on the junction of Bath Lane and Westgate Road.

The artwork *Ever Changing* was designed by Eilis O'Connell in 2005 and was commissioned as part of the Grainger Town street improvement works carried out all over the centre of Newcastle. It is a mirror-polished inverted cone reflecting an ever changing view of buildings and people. It is 6 metres (18 feet) high, made of stainless steel sheeting and set at 73 degrees to the horizontal. As you walk around the circular paved area forming the base the artwork, the mirrored cone reflects different buildings seen against the sky depending on the weather, time of day and different levels of activity on the street. The site of the artwork is very appropriate as this area has seen considerable change over the years. It is sited immediately to the west of the site of the West Gate. The gate was one of only two of the seventeen gates to have a bastion or outer defensive gate – the other being New Gate. The gate stood here from around 1265 until 1811, when it was removed to allow traffic to move more freely into the town. To the north, a large stretch of town walls have survived, together with the Durham Tower. The Rutherford Schools stood on Bath Lane in front of the town walls from 1870 until 1987. The landmark Essoldo Cinema used to stand on the corner of Thornton Street and Westgate Road from 1938 until the 1990s.

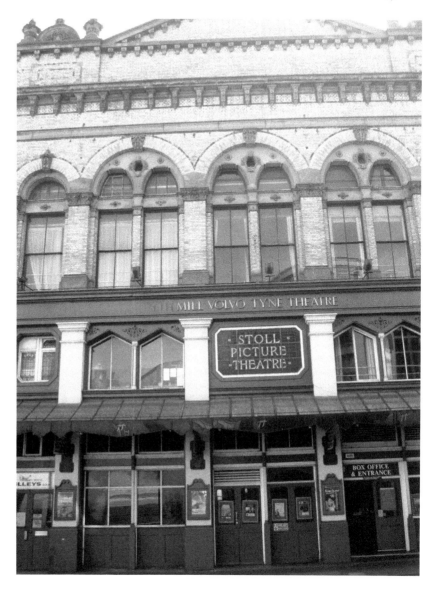

The Tyne Theatre and Opera House was built by Joseph Cowens and opened in 1867 as a theatre, and was converted to the Stoll Picture House in 1919. It reverted back to a theatre in 1985.

The Italianate pale-brick fronted Tyne Theatre and Opera House was built in 1867 by W. Parnell and founded by Joseph Cowan. It is the oldest purpose-built Victorian theatre in England. It was built by Joseph Cowan to provide an outlet for alternative and more radical theatre productions that might appeal to the less well off, who could not afford to go to the Theatre Royal. It was converted to the Stoll Picture Theatre in 1919 and was the first cinema to show talking movies. The Stoll started as a luxurious venue with a well-appointed cinema cafe. Later it developed a seedy reputation for showing adult movies and was closed in 1974. It was renovated after a fire in 1985. It is a Grade II listed building and was again under threat in 2002 when it was put on the English Heritage 'Buildings at Risk Register'. It reopened as the Journal Tyne Theatre and is now known as the Tyne Theatre and Opera House and continues to operate successfully.

Tyne Line of Txt Flow, Thornton Street

This artwork takes the form of a long metal strip of text messages sunk into the pavement. It follows the line of an underground stream – the Skinner Burn.

In Thornton Street there is an unusual artwork which forms a very thin stainless steel strip of text messages that follow a 140-metre long line back and forth across the street and even up and over street furniture. The artwork, called *Tyne Line of Txt Flow*, is by Carol Sommer, Sue Downing and William Herbert and was installed in 2005 as part of the Artworks on the Street project by Newcastle City Council and the Grainger Town Partnership. The messages are based on three sources: records from the time Charles I was held prisoner in Newcastle in 1746; from actual text messages made on the day of the Newcastle Sunderland derby match in 2002; and from the famous Vindolanda Tablets (2,000-year-old Roman writings on timber tablets that were preserved in a bog and discovered in the 1970s and 1980s at the Roman fort of Vindolanda beside Hadrian's Wall). One example from a Roman tablet states: 'Ive sent U 2 pairs of sox frm Sattua 2 pairs sandLs N 2 pairs of underpants'. Another message is from the commanding officer's wife at one Roman fort to another commanding officer's wife at another fort, where Claudia Severina sends a message to her friend Lepidina inviting her to come to her birthday celebrations on 11 September. The long flow of text also refers to the fact that under the surface of the street one of the ancient tributaries to the Tyne, the Skinner Burn, still flows in a culvert.

Grainger Memorial Fountain, Waterloo Street

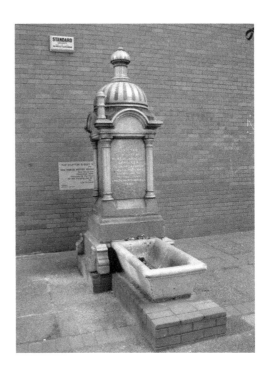

This memorial fountain to the memory of Richard and Rachel Grainger is situated at the southern end of Waterloo Street; it had been moved from Neville Street.

This memorial fountain to the memory of Richard and Rachel Grainger was erected by their daughter, Rachel Elizabeth Burns, in 1892 in accordance with instructions set out in her will. It was originally erected in Neville Street, but was moved to this secluded location in Waterloo Street some years later to make way for street improvements at a time when Grainger's achievements had been overlooked. During his lifetime, Richard Grainger was not universally liked – he was a ruthless man, not very sociable, not involved directly in politics, he was not philanthropic and only built for the rich. He lived at Elswick Hall and bought land in Elswick that overstretched his finances; he had to move to smaller premises eventually. He was too ambitious at times and upset some creditors by not paying bills on time, and almost bankrupted himself on a few occasions. He struggled as a developer until he became good friends with the wealthy John Clayton, who was the town clerk for Newcastle. John Clayton was not only a friend but acted as his personal solicitor and private advisor, and it was him who persuaded Grainger to come back to face his creditors in 1841 after he had left the town. His wife Rachel did his correspondence as well as having thirteen children – six sons and seven daughters. She died in childbirth in 1842 in Scotland. He lived with his family from 1842 at No. 36 Clayton Street West and had his offices at No. 28 Clayton Street West where he died suddenly on 4 July 1861. He died owing £110,000, but this was eventually paid off by 1901 due to rising land values of his assets and thanks to John Clayton's stewardship.

Lying-In Hospital, New Bridge Street

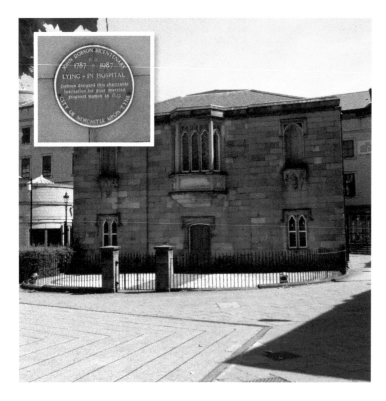

This building is mainly remembered as the headquarters of the BBC, who occupied the site from 1925 to 1987. It was built in 1825 as a maternity home for poor women.

The building was designed by John Dobson in 1825 in Tudor style as a lying-in hospital to replace an earlier building in Rosemary Lane, established in 1787. It was used until 1923 when a new site was developed at Jubilee Road to be opened by HRH Princess Mary and to be named after her. The building was taken over by the BBC in 1925 and converted into Broadcasting House. It was used until 1987 before being converted into offices. Dobson drew up the plans for free as it was originally for the poor and it was initially designed for seven patients. There were strict conditions of entry: the mother must have a fixed address, must be married, be free from disease and be able to provide clothing for the baby. Outside the building, the former road surface of New Bridge Street was converted into a new plaza in 2001 making a new pedestrian area with a unique floor covering, which forms the artwork called the *Blue Carpet*, installed by Thomas Heatherwick (now famous for designing the 2012 London Olympic Cauldron) – he used broken sherry bottles to give the distinctive blue colour. There were 22,000 tiles used and the council has a further 1,300 in storage to carry out repairs. The carpet draws together buildings into a newly formed square, providing an open area for events. The carpet has been peeled back in places to form benches, and the project includes the elegant laminated cedar wood spiral staircase in the shape of a falling ribbon, linking the square with the bridge over the motorway.

John Dobson's House, New Bridge Street

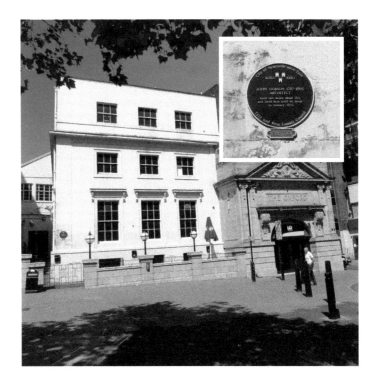

John Dobson designed his own home in 1823 and lived here until 1865. The Oxford Galleries were built on his garden in 1925. The ballroom/nightclub featured in the film *Get Carter* in 1971.

John Dobson designed his own house and lived in it from 1823 unitl 1865. His daughter lived here for a further forty years before it became a cheap boarding house and then became part of the Oxford Ballroom complex. It was built in 1823 of restrained design, unlike many of the buildings he designed for others. The design has been altered over time and is constructed in painted stone with a honeysuckle frieze and bracketed window cornices on the main floor. The house originally had a large garden to the rear. Dobson enjoyed gardening – a legacy from being brought up in Chirton where his father had a market garden. The building and former gardens are now occupied by a nightclub and looks like an industrial unit when viewed from above. The former Oxford Galleries Ballroom was built in the 1920s and has a fine front but is just a shed behind. It was last known as Ikon but was formerly known as Tiffany's as well as many other names. It featured as a nightclub exterior in the cult 1971 film *Get Carter*. Planning permission was granted in 2014 to redevelop the nightclub to form three blocks of flats to house 305 students. The Oxford Galleries portico will, however, be retained, as too will John Dobson's house, which is a listed building and will be converted into a standalone villa and used as a restaurant and café bar. John Dobson Street, opened in the late 1960s as a bypass and service access road for Northumberland Street, was named after him but is not a grand street like Grainger Street and Clayton Street. It is a disappointing reminder of his legacy to the city.

Plummer Tower, off Market Street

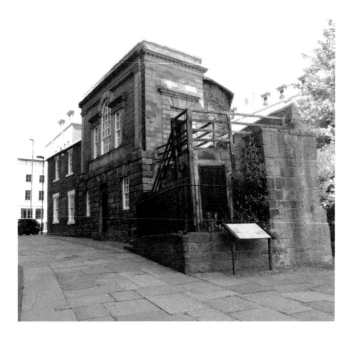

This well-preserved tower from the town walls was occupied by the Cutlers' Co. and later by the masons who took it over in 1742 and gave it a facelift.

The Plummer Tower dates from the late thirteenth century and was a tower on the eastern section of the town walls with a D-shape facing east to overlook the walls and ditch. During the Civil War, a bastion for artillery was built on its curved outer face above the original medieval stonework; a short section of town wall adjoins the south side. It is sometimes referred to as the Carliol Croft Tower or the Cutler's Tower. The Plummer family were leading merchants and politicians in the thirteenth and fourteenth centuries. It was used for meetings of the Cutler's Company in the seventeenth century before the Masons took it over in 1742. They repaired it and gave it a facelift, with a new classical-style façade built on the west side. The wall, extending northwards from the tower, was demolished in 1811 and the rubble used to form the base of the North Shields Turnpike road. The tower was later used as a private house and then as an annexe of the Laing Art Gallery.

The area inside the town wall at this point was one of the last areas of land inside the walls to be developed and was known as Carliol Croft. The site to the south of the Plummer Tower, now the site of the former Telephone Exchange, was developed as a new site for Newcastle Newgate Gaol. The gaol was built in 1828 at a cost of £35,000 and was designed by John Dobson. It was based largely on the ideas of the great prison reformer John Howard, who advocated a more humane approach to the design of prisons. It introduced the separation of criminals on a basis of sex, age and nature of the crime. It comprised a central inspection tower with radiating wings enclosed by a 25-foot high wall. The gaol was demolished in 1925, and in 1931 the new Telephone House was opened.

Fire Station, Pilgrim Street

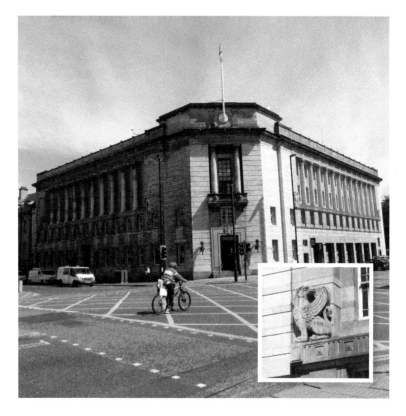

This impressive 1930s building was built for the fire brigade as well as the police, and included a magistrates' court. It features a griffin – the emblem of the fire brigade.

The magistrates' court, police station and fire station on the corner of Pilgrim Street and Market Street were built in 1931–33 by Cackett, Burns Dick & Mackellar, from Portland Stone. The police station replaced an earlier police station situated on the site of the fire station, which had moved there in 1874 after being based in the Manors area from 1831–74. It caused controversy when it opened as the new centralised police station led to the closure of six local police stations, which were replaced by police boxes and the loss of forty-nine policemen. The building also had a revolving mahogany door leading to a large banking style hall and no police guard at the entrance. The new building provided accommodation for twenty-one married police/firemen, a children's playground on the roof, a gymnasium and a small cinema. The fire station features a sculpture of a mythical griffin – the emblem of the fire brigade, which, according to the programme issued at the building opening in 1933, stands for 'power, watchfulness and swiftness to act, qualities equally appropriate to the operation of the law as to the duties of the fire brigade'. During the eighteenth and nineteenth centuries, insurance companies provided primitive fire engines and crews, and they would only put out fires in buildings insured by their company, indicated by a plaque on the wall outside.

Swan's Plaque, Carliol House, Pilgrim Street

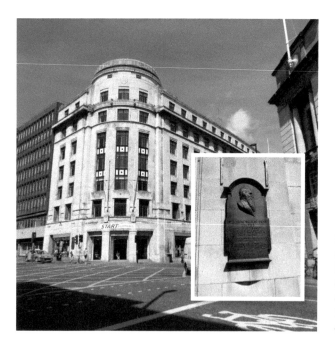

Sir Joseph Swan, the inventor of the incandescent light bulb, has a plaque erected to him on the Pilgrim Street elevation of Carliol House, the former Newcastle Electricity Co. offices.

Carliol house was built in 1927 as headquarters of the Newcastle-Upon-Tyne Electric Supply Co. Ltd. It was designed by Leonard J. Couves & Partners of Newcastle in association with John Burnet & Partners. There is a plaque on the wall on Pilgrim Street to Sir Joseph Wilson Swan 1828–1914. He was born in Sunderland, lived in Gateshead but worked in Newcastle. He joined John Mawson, Chemist & Druggist in 1846 after Swan worked as an apprentice druggist in Sunderland. Swan was allowed a lot of opportunity to carry out experiments and later became a partner with John Mawson in the Mawson Swan Firm – later to become Mawson, Swan & Morgan in Grey Street. They started pioneering photography and then experimented with electric lamps. He was the inventor of the incandescent light bulb in 1878 and demonstrated it at the Literary and Philosophical Society in February 1879 in front of 700 people. In 1882, he set up a factory to manufacture bulbs in South Benwell. He did not register the patent immediately, and in America Thomas Alva Edison patented his invention in November 1879 and set up his company Edison Electric Light Co. in Britain in March 1882. Edison took legal action against Swan when he heard about Swan's company, but no clear decision was made on who was first to invent the light bulb, so the two companies merged in 1883 to form the Edison and Swan Electric Light Co., with Swan having 60 per cent and Edison 40 per cent. Production moved to London and the Newcastle factory closed. Swan also invented a lot of new processes in photography before this and patented them, for example in 1864 he invented a carbon process for producing photographic prints that did not fade.

King Charles I Plaque, Market Street

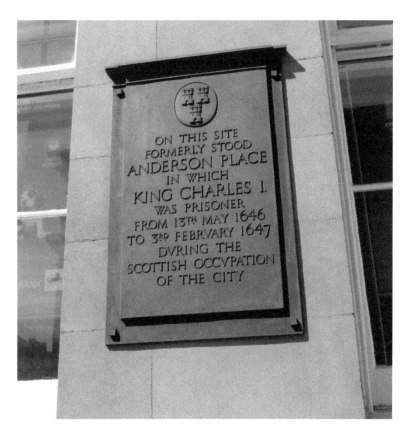

Charles I was held prisoner for almost a year in the house that existed on this site from 1646 to 1647. It was the biggest house in Newcastle and he played golf during his stay.

Following defeat in the Civil War, Charles I was held prisoner by the Scottish Army at Newcastle for nine months between 13 May 1646 and 3 February 1647. Newcastle had been a very important Royalist stronghold during the Civil War and held out for two months against the Scottish Army, who were supporting the Parliamentarians, during the Great Siege of 1644. Following on from the siege, the Scots occupied Newcastle until Charles I left in 1647. Although technically a prisoner, Charles I lived in the largest house in the town called Anderson Place, which was a mansion set in its own grounds, and he was also allowed to play golf on the Shield Field during his stay. He was eventually 'sold' back to the English Parliamentarians where he eventually met his fate on the chopping block. Some years later, when his son Charles II was restored to the throne, it is said he conferred on the town the motto *Fortitur Triumphans Defendit* (Triumph by Brave Defence). Anderson Place is also known as Newe House and was built following the Dissolution of the Monasteries on the site of a Franciscan friary and a nunnery dedicated to St Bartholomew. The house survived until the 1830s, and the grounds were redeveloped to form what is now known as Grainger Town.

Portuguese Ambassador's Plaque, Grey Street

Jose Maria De Eca De Queiros, who was Portugal's equivalent of Charles Dickens, lived in Newcastle for five years from 1874 where he wrote some of his best work. The plaque is on the corner of High Bridge.

This plaque to Jose Maria De Eca De Queiros (1845–1900) on the corner of Grey Street and High Bridge records the fact that one of the most famous Portuguese novelists, the Portuguese equivalent to Charles Dickens, lived in Newcastle for five years between 1874 and 1879. At the time he was working as a Portuguese diplomat and lived at No. 53 Grey Street, during which time it is said he did his best writing and he published his best and most controversial novel *The Crime of Father Amaro*. In it he highlighted corruption and greed in Portuguese society as well as questioning religious beliefs. Despite this he still received a state funeral when he died in 1900. He was not impressed with British society, but was fascinated at how odd it was – he also lived in Bristol and London. He is quoted in his letter during his stay in Bristol as writing, 'Everything about this society is disagreeable to me – from its limited way of thinking to its indecent manner of cooking vegetables'. Perhaps once he got to spend some time in Newcastle and sampled the local mushy peas and pease pudding his creative juices were enlivened to enable him to produce his best works!

Morrison Plaque, Cloth Market

A plaque is installed in the paved area opposite Balmbra's Music Hall site to Robert Morrison, who is more famous in China than Newcastle as he translated the Bible into the Chinese language.

Opposite the famous Balmbra's Music Hall in Cloth Market stood the old town hall. When it was redeveloped in the 1980s, a new square was created, named Morrison Court after a former resident of Newcastle, more famous in China than in his own country. Robert Morrison moved to Newcastle aged three and was the youngest of eight children. Robert Morrison lived in a house in a courtyard on this site in Newcastle from 1785 to 1803 and worked as a last-maker. He moved to London in 1804 to train as a congregational minister before moving to Portsmouth in 1805 to train as a missionary. He then lived in London to learn Chinese and was ordained as a minister aged twenty-five. Morrison then travelled to China in 1807 and was the first protestant missionary to do this. He was also employed as a translator for the East India Co. – a job he kept for twenty-five years. While there he translated the Holy Scriptures into the Chinese language for the first time; it took him twenty-five years of his twenty-seven in China to complete and then get the work published. He also published a dictionary of the Chinese language and founded an Anglo-Chinese college in Malacca. Morrison only came back to Britain once during his time in China – in 1824. He was born in Morpeth on 8 January 1782 and died in Canton in China on 1 August 1834, aged fifty-two. The plaque was originally erected by the Newcastle Bible Society in 1897 close to the present location.

Adam Figure, St Nicholas Cathedral

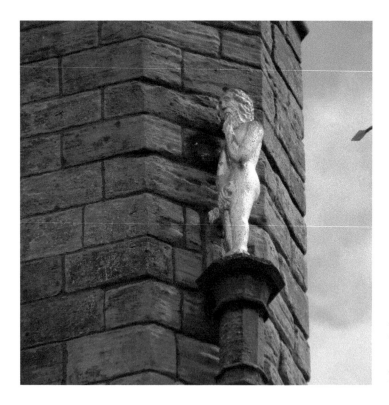

High up on the corners of the lantern tower of St Nichols Cathedral are four gold figures, one of which is Adam.

The cathedral church of St Nicholas was built originally as St Nicholas' parish church, and the present building dates from the fourteenth and fifteenth centuries. The earliest reference to the church is from the 1190s. It was one of four parish churches that included St Andrew's, St John's and All Hallows (later All Saints). The Lantern Tower was built in 1448 and served as a navigation point for ships using the River Tyne for over 500 years. A barrel of tar was placed in the lantern to provide light. Robert Rhodes donated the money for the Lantern Tower, and his coat of arms can be seen on the base of the christening font. The south side extension was built later to support the tower, which was leaning to the south. In 1736, the Tomlinson Library was given to the cathedral and an extension to the south was built to house it – the collection is now held in the Central Library. On the corner of the tower are four gold figures: Adam and Eve face onto the north side and Aeron and David face to the south. It became a cathedral in 1882 when Newcastle became a city. Local people objected to this as they wanted to remain a town rather than city. The Major Bell that strikes every hour was donated by Maj. Anderson of Anderson Place. Cuthbert Collingwood was baptised and married in the church and has a bust and plaque within the cathedral. Thomas Bewick, the famous woodcarver, had his workshop to the rear of the cathedral.

Vampire Rabbit, Cathedral Buildings

Above left: The famous 'Vampire Rabbit' looking directly at the rear of St Nicholas Cathedral.

Right: The very ornate rear doorway of Cathedral Buildings that front onto Dean Street has the Vampire Rabbit on top, but nobody knows why.

The 'Vampire Rabbit' or 'Hare' is the strange sculpture looking down from above a doorway at the back of cathedral buildings. What nobody seems to know for certain is why it was put there in the first place – overlooking the rear of St Nicholas Cathedral. There have been a few guesses including that it was inspired by gargoyles, but St Nicholas' does not have any traditional ugly faced demons on the building. Another suggestion was that it was named after an architect called Hair, but the architects were called Oliver, Leeson & Wood. The building itself was built between 1900–01 and has a very unusual ornate appearance, with Jacobean, Queen Anne and Baroque influences. It is also different from many buildings in Newcastle as it has a lot of coloured decoration. It was built as a five-storey office block with shops on the ground floor. The doorways to the shops are very decorative and feature cast-iron ionic columns. The oriel windows fronting Dean Street also have decorative panels between them, making the building stand out from the others. This challenging design may have led the architects to put something striking and memorable above the very elaborate back doorway. It has certainly proved to be a talking point ever since.

Stone Coffins, Amen Corner

Three very old stone coffins lie on the surface of what was once a very congested graveyard to the south of St Nicholas Cathedral. It was closed in the 1850s following outbreaks of cholera.

Three very old stone coffins were found when the original cemetery was abandoned in favour of burials in new cemeteries on the edge of Newcastle. The coffins are now on display on the south side of the cathedral on the small part of what remains of the original extensive graveyard. Beyond is the narrow alley known as Amen Corner. The area was originally part of the graveyard and was fenced off from the street. Burials in Newcastle were stopped in 1854 after the breakout of cholera in 1853, and new cemeteries were built at Jesmond and Elswick. Only a few gravestones remain to remind visitors of the presence of a graveyard that over the years was built higher and higher as more bodies were interred on top of others. At times, old burials were dug up and the bones stored in a charnel house, which occupied a crypt on the north side of the church and is now used as a chapel. One of the other gravestones records that Lucino, a native of St Georgio near Como in Italy, is buried here. Another records the death of Thomas Reevely who died aged thirty-one in 1775 and was erected by his master Mathew Bell Juner Esq. whom he had served faithfully and honestly for many years. Also, at the rear of the cathedral, opposite the vampire rabbit, is an impressive table monument to Joseph Barber, who died in 1781 and was a bookseller based in Amen Corner. The lane leading to St Nicholas Street is called Amen Corner and is reputed to have got its name from the processions that took place around the outside of the church. This corner was the point in the service where they reached the 'amen'!

Collingwood's Birthplace, Side

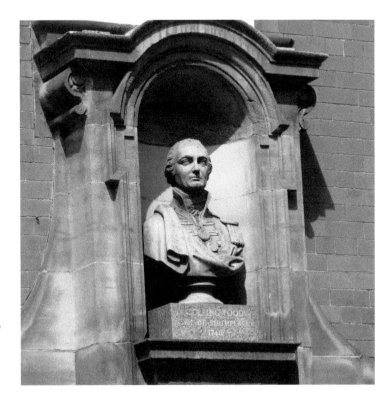

Admiral Cuthbert Collingwood, the victor of the Battle of Trafalgar in 1805, was born on this site in 1748. He was married in St Nicholas church.

Cuthbert Collingwood was born on 26 September 1748 at the Side in Newcastle. Milburn House was built on the site of the original house, and a bust to Collingwood can be seen over the door. He was baptised in the parish church of St Nicholas and attended the old grammar school, which was on a site opposite the Central Station. Collingwood was a scholarly man and read classics on his voyages. He spent forty-nine years in the navy and was at sea for a total of forty-four years. He joined aged twelve and worked his way up the ranks as he travelled all over the world. Collingwood was a very good friend of Nelson, despite both having totally different characters. Collingwood married Sarah Blackett at St Nicholas' church in Newcastle, and had two daughters, Sarah and Mary Patience, but he saw little of them. The family later moved to Morpeth to live, but Cuthbert spent little time there. The Battle of Trafalgar took place on 21 October 1805, with Nelson in command. Collingwood was first to break through enemy lines, and this led to Nelson's famous remarks 'see how nobly that fine fellow goes into action'. Shortly after this, Nelson was fatally wounded and Collingwood took over command and led the navy to its famous victory. He did not return to England but commanded the Mediterranean fleet until he died in 1810. His body was returned to be buried in St Paul's Cathedral beside his friend Nelson.

Black Gate, Side

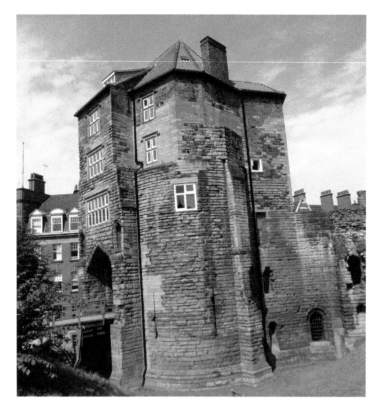

The Black Gate was built as a bastion to the North Gate of the castle walls. It was later extended and converted to a number of uses and was named after a tenant, Patrick Black.

The Black Gate was built as a bastion beyond the original north gate of the castle curtain walls. It was built as an added fortification as this side of the castle was the most vulnerable – it was not protected by a steep slope like the rest of the castle walls, which followed the top of the promontory overlooking the Tyne. In front of the gate was a deep ditch with a drawbridge over it; behind the gate was a portcullis. The Black Gate was deliberately built with a dog-leg in it to prevent any enemy being able to storm through to the North Gate, giving the defenders a better chance to defend. The Black Gate was converted into a wealthy merchant's house by Anthony Stephenson in 1618–19. It received its name from a tenant of the converted gate house called Patrick Black. The Society of Antiquaries for Newcastle took responsibility for the building in 1883 to restore it as a library. Many other buildings were built up over time against the Black Gate and the Curtain Wall linking it to the North Gate. One was a pub called the Two Bulls Heads, which may have included part of the Black Gate. One of the previous owners, John Pickles, has left his mark on one of the high-level stones facing south, just below a window – 'Pickles 1676' is inscribed into the stone. The Heron Pit was a former prison or oubliette where prisoners would have been lowered into the pit, which had no windows or any other means of escape.

Saxon Church, Castle Garth

The remains of a Saxon church were found under a railway arch close to the castle; the settlement at the time was called Monkchester.

Underneath the railway arches are the remains of a Saxon church or chapel dating back to around the eighth century. After the Romans left Britain, around AD 410, there seems to have been a gap in the occupation of the Roman fort area of some 300 years. Evidence for this comes from excavations and the discovery of a large number of graves in the area. These burials extended around the present Keep (strongest tower of the castle), under the railway arches, as well as under the pavements of St Nicholas' Street and Castle Garth. The burials were identified as Christian, with the bodies laid out on an east–west axis, with a mixture of men, women and children. The graves dated from the sixth to late twelfth centuries and were presumably associated with the Anglo-Saxon settlement of Monkchester. It is believed burials continued during and after the building of the first castle from 1080, but stopped when castle was built in stone in 1178. Extensive excavations, undertaken between 1973 and 1992 by Barbara Harbottle and John Nolan, uncovered more than 660 graves. The stones have been laid out on the surface to show where the church once existed. It is only on the north side of the church where the original stones have been used (marked with a cross hatch), the others on the east and south sides are speculative.

Roman Fort, Castle Garth

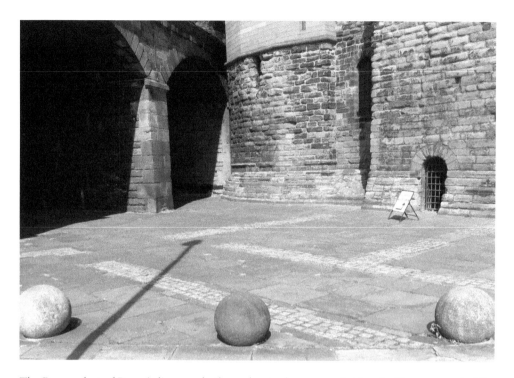

The Roman fort of Pons Aelius was built on the site later occupied by the Norman castle. The locations of some of the buildings discovered are marked out on the surface close to the keep.

The remains of the original Roman fort of 'Pons Aelius' were found during various excavations in the precinct of the Norman castle beside the massive Keep building. The location of the remains of various buildings has been marked out on the present surface by the use of different paving stones. To the west of the Keep, and extending partly under it, is the Headquarters Building (Principia). To the west of the Headquarters Building, and mostly under St Nicholas' Street, is the commanding officer's House (praetorium). Under the railway arches to the north is the west granary (horrea) and along the north side of the Keep is the east granary. These buildings are always found in the central part of a Roman fort with the soldier's barracks either side – in this case to the north and south. It is thought that small parts of barrack buildings were found either side of the Keep, and a small section of the north perimeter wall was located east of the Black Gate. It is thought that the Roman fort occupied most of the headland later occupied by the 'New Castle', but did not have the traditional playing-card shape of most Roman forts as the shape of developable land on this site precluded this. It is still thought that the fort had four main gates, one on each side. It is not certain that Hadrian's Wall directly connected to the fort as the wall was built in AD 122 whereas the fort was built some years later, around AD 200.

Castle Walls and Well, Castle Stairs

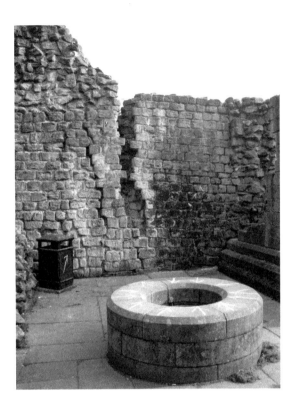

The best preserved section of the original castle walls lie beside Castle Stairs, which pass through the south postern gate. The remains of a well were also found here.

The 'New Castle', built by the Normans, originally in timber in 1080 and replaced in stone later in 1178, did not just comprise of the Keep, which today is often seen as the only historic remains. All that remains are the South Postern Gate, a section of the south curtain wall, a small part of the east curtain wall, some remains of the twelfth-century North Gate, the Black Gate and part of the ditch. The most impressive remains of the curtain wall lie on the west side of the South Postern Gate through which the castle stairs still climb up from the close, linking the lower town with the castle. There are also the remains of an ancient well inside the walls to the west of the castle stairs. These walls, almost full height, continue along to the High Level Bridge and turn north towards the Bridge Hotel. They demonstrate how well defended the castle must have been prior to the building of the town walls around 1300. Before the town walls were built, residents of Newcastle and nearby settlements could crowd into the castle walls for protection. The area within the walls was called the Castle Garth and remained under the control of the crown – this was also part of Northumberland rather than Newcastle Corporation. Over time it became very congested as traders who were not members of the guilds could operate from within the Castle Garth area without having to comply with the strict rules of the Newcastle Guilds. The Keep was used as the Northumberland County Gaol.

High Level Bridge, St Nicholas Street

Robert Stephenson designed the first double deck road and rail bridge in the world. It was opened by Queen Victoria in 1849.

George Stephenson had originally surveyed the route for the Eastern railway into Scotland in 1838. His son Robert Stephenson went on to design both the High Level Bridge over the Tyne and also the Royal Border Bridge over the Tweed at Berwick. The rail bridge was opened in 1849 by Queen Victoria and the road bridge underneath was opened a year later and was originally a toll bridge, which lasted until 1937. Robert Stephenson was assisted in designing the bridge by his fellow engineer Thomas Harrison, who is often forgotten, but there is a plaque to record this on the north side of the bridge close to the Bridge Hotel. In addition, this plaque also records that the contractors for the iron works, who provided the cast iron for the bridge, were the local Gateshead company of Hawks, Crawshay & Sons. The bridge was extensively restored during the late 1990s at the cost of over £40 million, and amazingly this was all carried out without interruption to the rail services on the upper deck. The roadway was closed for some years and the carriageway was reduced in width for safety reasons and made into a one-way system for buses and taxis. The original cream colour of the bridge was reintroduced during the restoration of the structure and after the removal of up to seventeen coats of paint. The bridge has featured in a number of films and TV programmes; one of the most atmospheric was the film *Stormy Monday* (1987) starring Sting.

Town Walls, Orchard Street

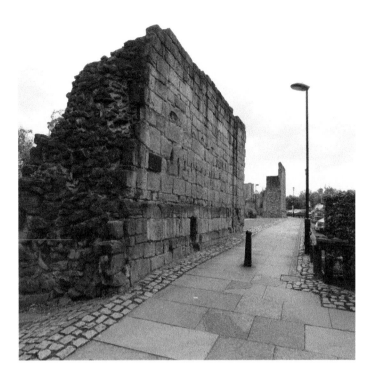

A large section of the town walls was hidden from view for many years behind the Central Station as they were surrounded by the Federation Brewery until it was demolished in 1985.

A large section of town wall exists in two parts between Forth Street and Hanover Street, close to Orchard Street. It used to be hidden inside the Federation Brewery until 1985. The brewery actually got consent to knock down a section to improve the internal operations of the brewery. The wall itself was built around the early 1300s, and at the Hanover Street end there was a substantial tower at the top of the slope down to the river known as the White Friar Tower. It was named after the Carmelite Friars, who had a friary just inside the wall at this point. The friary was established on the site around 1307 after they moved from a site at Wall Knoll beside the present Sallyport Tower where they had been since 1262. They took over the site from the friars of the Sack, who had occupied the site since 1266. Around 1300, the Newcastle Carmelites numbered twenty to thirty. The friary was dissolved in 1539 when its membership consisted of a prior, seven friars and two novices. The tower was later occupied by the company of Waller's, Bricklayers & Plasterers from 1614. It was demolished between 1840 and 1844. The town wall close to the tower was undermined during the Civil War in 1644, creating a major breach. It was repaired and reinstated in 1745 during the Jacobite Rebellion. To the west of the wall was a large ditch, which later became an orchard in the eighteenth century. Later industrial development lost all traces of the orchard and the former Carmelite friary, although excavations carried out in the 1960s have found the site of the friary mostly under Forth Street.

Stephenson Works, South Street

The first railway locomotive factory in the world was opened in 1823 in South Street behind the Central Station. It was named after Robert Stephenson, who was aged twenty at the time.

The first purpose-built locomotive factory in the world was built on this site in 1823 and was called Robert Stephenson & Co. after the twenty-year-old son of George Stephenson, who was showing a lot of promise in his early years. The company was set up by George and Robert Stephenson together with their business partners and supporters Edward Pease (1767–1858) and Michael Longridge (1758–1858). Inside the factory, famous locomotives were designed and constructed. These included locomotives for the world's first public railway in 1825 from Stockton to Darlington. A plaque outside the building records some of the locomotives built here: *Locomotion No. 1* (1828), *Rocket* (1829) built for the Liverpool and Manchester Railway, and *Planet* (1830) among many more. The firm started on the corner of Forth Street and South Street, but before 1829 it had moved to premises at the bottom end of South Street. Over the years it expanded to take over most of South Street, including land to the west. In 1902, the whole company left Newcastle and moved to more spacious premises at Darlington. Part of the old works was taken over by its neighbours, Hawthorn Leslie's loco division. In 1937, the firm returned to Newcastle. They took over Hawthorn Leslie's loco division and became Robert Stephenson and Hawthorns Ltd. The firm itself was lost in the mergers of the 1950s and 60s and disappeared altogether when its works were closed at Newcastle in 1961 and Darlington in 1963. No. 20 South Street was developed as a Stephenson museum in 1988 by the Robert Stephenson Trust, but this closed in 2008.

Rutherford Fountain, Bigg Market

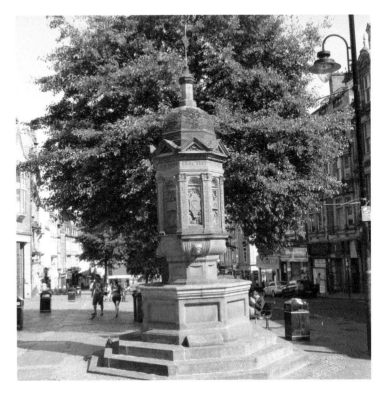

John Rutherford was a doctor, preacher and educationalist who helped the poor to get an education. He was a leader of the temperance movement and his fountain states 'water is best'. Unfortunately it is situated in the Bigg Market surrounded by pubs.

The Rutherford Drinking Fountain memorial was first unveiled by Joseph Cowen in 1894. It was paid for by Charles E. Errington as a memorial to John Hunter Rutherford – a leading temperance advocate and local doctor, preacher, educationalist and friend of the poor. It was originally outside St Nicholas Cathedral, but was moved in 1901 when Queen Victoria's monument was installed. It was again moved in 1998 to its present position when pedestrianization works were carried out in Bigg Market. On the side are the words 'Water is Best', which is ironic as it is located in the heart of one of the main drinking centres of Newcastle. Rutherford established a school in Bath Lane and introduced breakfast for pupils before school started to ensure children were properly fed. He even opened the school on Saturday to give children breakfast, which most would not have got at home.

The Bigg Market, fronting the parish church of St Nicholas, was the original medieval marketplace and has many burgage plots leading off it, such as that containing the Old George. As there was a tax on frontage plots, people built long thin buildings between narrow alleys or *chares*, for example Pudding Chare. The marketplace was used as a market on Tuesdays, Thursdays and Saturdays until very recently. Things may change in the future as Lottery funding has been approved to carry out major environmental works in the area.

Nuns Building, Newgate Street

This building is not as old as it looks. It looks medieval to reflect the fact that there was a nunnery on the site, but it was built hundreds of years later.

The building at No. 22 Newgate Street, on the corner of Nuns Lane, looks like an ancient Gothic building dating back to medieval times. It has certainly confused and misled a number of people over the years who thought it dated from an earlier period. It was erected by Maj. Anderson and was built to remind people that the site was once the home of the nunnery of St Bartholomew, founded in the twelfth century. The building is described by Nicholas Pevsner, in his book on the buildings of Northumberland, as having been put up in 'an antique fashion', with 'cusped lights and blind cross slits, the Anderson Arms on the narrow turret like end bays and eroded shield on the other.' The building originally on the site was the gatehouse to Bartholomew's Nunnery, which stood on the west end of the Anderson Estate. The building was praised by the historian McKenzie in 1827 as being a fitting reminder of the sites history. Brand, another famous historian, believed this site was the main gateway into an extensive plot of around 8 acres, with a range of buildings, orchards, vegetable and herb gardens and fields for grazing sheep and cows extending down to the valley of the Lort Burn that separated the site from the monastery of the Franciscan Friars on the other side. The nunnery was said to be very popular for educating the daughters of nobles and even royalty. It is believed that after the death of Malcolm III of Scotland, his Queen's mother and sister took refuge here as they were both English. From the fourteenth century, the popularity of the nunnery declined, and by the time of the Dissolution in 1540 only nine nuns and the prioress occupied the buildings. The grounds of the nunnery and the Franciscan friary were incorporated into the grounds of the New House or Anderson Place until Richard Grainger developed the site in the 1830s.

Yates Building, Grainger Street

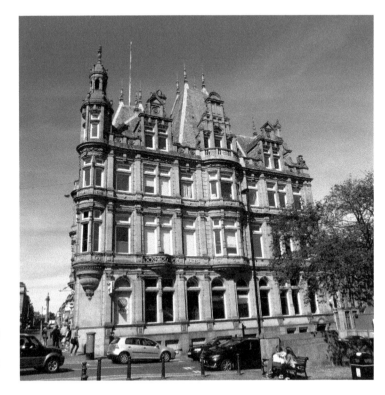

The building looks like a French chateau and was built originally as the headquarters of a gas company and has a gas flame at the top. Most people remember it as Wengers department store.

Yates building, at the foot of Grainger Street, was originally built for the Newcastle and Gateshead Gas Co. in 1887, as signified by gas burners on the roof. It was designed by John Johnson in a French chateau style. Many people from Newcastle remember the building as Wenger's Department Store, which occupied the site for many years. It has been said to be the best non-Classical building on Grainger Street, and the flamboyant seventeenth-century French chateau style stands out on the prominent corner when viewed from the south, against the more modest style of architecture on the rest of the street. The architect John Johnson was well known for his careful attention to detail and use of decoration, but even by his standards this building stands out. It is an early steel framed building, which enabled him to provide a light interior as well as being able to add a range of bay windows, decorative string courses, ornate dormers and turrets, with an array of finials on the roof providing a dramatic skyline. This part of Grainger Street was not part of the original that ended at the Bigg Market in the 1840s. The main link to St John's church was by a narrow alleyway known as St John's Lane until the street was extended in 1868 to improve the link between what we know as Grainger Town and the Central Station. Before that the main route used by horses, carriages and wheeled vehicles would have been along Neville Street and Collingwood Street to the east and Clayton Street to the west.

Humorous Brass Plaque, Grainger Street

A number of artworks exist on the pavements of Grainger Street between Bigg Market and Neville Street. Some feature humorous and pointless comments.

Grainger Street was at the heart of the Grainger Town Project in the 1990s and became the centre for pavement art in Newcastle through a scheme called 'Arts for the Streets'. Three different artworks can be seen between the Bigg Market and Westgate Road. Two are humorous and were installed by Newcastle Artist Rupert Clamp and one is very artistic by Catherine Bertola. Four brass plaques have been installed in the pavement and they look as if they record an important event that took place at that spot, but quickly the reader realises they are just silly statements, and those of a certain age may look around for the 'candid camera'. The four plaques installed in 2004 record:

Nathan Walker walked past here 47 times during 1968. On the 21st May 1968 he looked up

Ann Huxtable waited here for a friend who did not arrive 8th December 1952

Mrs Mary Howard adjusted her hat in the reflection in this window 3rd June 1921

David Williams watched the rain from here 7th September 1979

Rupert Clamp's second artwork was installed in 2002 by cutting individual letters in the granite kerb stones, turning the corner from Westgate Road into Grainger Street outside St John's church. It has to be read from Westgate Road and reads, 'FROM HERE IT IS NINE THOUSAND TWO HUNDRED AND FIFTY SEVEN CENTIMETRES (How are you feeling?) TO HERE'

Catherine Bertola's artwork, also from 2004, is called *Under Your Feet* and takes the form of welcome mats outside the front of four doorways on Grainger Street. The engraved granite doormat is made up using a decorative design taken from part of an original architectural design feature on the building itself.

St John's Church, Westgate Road

There is an unusual coat of arms on the south side of St John's church fronting onto Westgate Road (shown above). It looks like a whippet and three stotties, but dates from the fifteenth century.

St John the Baptist church was mainly built in the fourteenth and fifteenth centuries, originally built as a chapel to St Nicholas' church. On the south side, above a main window on a projecting gable facing the graveyard, is a plaque with a coat of arms on it. It takes the form of a dog over three circles, or as we City Guides refer to it, as a 'whippet and three stotties'. It is the coat of arms of Robert Rhodes, who died in 1474 and was a large benefactor to St John's church. Further references to Rhodes are found recorded on a boss in the tower vault. Above the arms are the Latin Words *orate proanima* with Roberti Rodis below, which means 'pray for the soul of Robert Rodes'. The tower contains eight bells. There is a plaque on the tower, above the clock on the south face, which says the building used Roman cement during restoration – unfortunately the date has eroded away. The church was used by Richard Grainger when he lived in Clayton Street from 1842, and there is a memorial tablet to him and his wonderful legacy to the people of his native city, erected in 1888 inside the church. The Milecastle pub is named after a Roman milecastle that was found nearby on Westgate Road under the arts centre. It was built as the Trustees Savings Bank in 1863 for Newcastle Savings Bank by J. E. Watson. The motto in the pediment on the front elevation has the arms of Newcastle decorated by seahorses; the motto on Grainger Street has a beehive with cornucopia with the motto 'INDUSTRY', suggesting that work is the best guarantee of plenty. The building almost collapsed under renovation in the 1990s and only the façade remains. The original building had no doors onto Grainger Street as at that time it was still St John's Lane, six years before the present Grainger Street was extended.

Man with Potential Selves, Grainger Street

This man looks as if he has had one drink too many as he supports himself horizontally on his elbow. He is part of an artwork with two other figures north of Neville Street.

Three life-sized sculptures of men are located on Grainger Street between Neville Street and Westgate Road, two of which blend in with the crowds of people. However, one causes people to stop and stare. The painted bronze figures were installed in 2003 by artist Sean Henry as part of the Grainger Town Street Art scheme and are collectively called *Man with Potential Selves*. The figure closest to Westgate Road, mounted on a plinth and wearing an overcoat, is standing looking down Grainger Street at another figure of the same man walking towards him at street level in his shirt sleeves, as if he has just come out of the Metro underpass. The third figure closest to Neville Street is mounted on a low wall close to the Metro Station underpass and is horizontal, balancing on his elbow facing towards the buildings on the west side of Grainger Street. He is wearing a jacket as well as a smirk on his face to suggest 'I bet you cannot do this!', and his feet are bare. The figures are said to offer potential: one is said to have his feet on the ground; another is walking down a prescribed path of life in a determined manner; and the third is just a dreamer.

Westgate Road

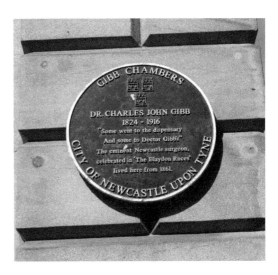

The famous Dr Gibbs, referred to in the Geordie anthem *The Blaydon Races*, had his house here on Westgate Road to the east of the Assembly Rooms.

Dr Gibb, who has been immortalised by famous Geordie anthem 'The Blaydon Races', written by Geordie Ridley in 1862, had a medical practice on Westgate Road, which is now called Gibb Chambers and is currently used as offices. The song records that after a number of the racegoers fell off the bus, which had lost a wheel on the way to Blaydon, some came back home to seek medical help and

> Some went to the dispensary,
> And some to Doctor Gibb's,
> And some sought out the Infirmary,
> To mend their broken ribs

Dr Charles John Gibb (1824–1916) was an eminent Newcastle surgeon who lived at this address from 1861. Outside the surgery door, down a passage at the side of the building, was a doctor's bell, or an old-fashioned speaking tube. Visitors would be able to speak to the doctor through the tube to tell him what their ailments were before he needed to come to see them; presumably this was an early security device. He must have had a busy day on 9 June in 1862. The dispensary referred to at that time was located in Nelson Street beside the Grainger Market after being founded in 1777 in Side to provide medicines for the poor. It then moved to Low Friar Street or Dispensary Lane, and moved again to Nelson Street in 1839. It later moved to New Bridge Street in 1928, remaining there until 1976 where there is still a dispensary sign on the building now in use as commercial premises. The Infirmary was situated on Forth Banks to the west of the Central Station in the area now occupied by the 'Life' buildings, and had been there since 1752 before moving to the Royal Victoria Infirmary, which opened in 1906.

Joseph Cowen (1829–1900), known locally as 'the Blaydon Brick' because he owned Blaydon Brickworks and lived at Stella Hall, was one of the most influential figures in Newcastle in the nineteenth century. He was Liberal MP for Newcastle between 1874–86 and was described as a fiery orator and a great champion of radical causes. He was a friend of Giuseppe Garibaldi, the Italian freedom fighter, and led a delegation of like-minded men to meet Garibaldi when he visited Newcastle in 1854. There is a plaque in Nelson Street to record his visit along with Cowen's two other freedom champions Kossuth from Hungary and Garrison from America. It has been said that Cowen even smuggled guns to some of the freedom fighters by concealing them among loads of bricks from his brickworks. Cowan was also the proprietor of local newspapers including the *Newcastle Chronicle* (which still survives today) and the *Northern Tribune*, and used these papers to promote his many causes. He is said to have established the 'Dickie Bird Society' in 1876, which campaigned against animal cruelty, as well as the Northern Reform Union to argue for voting rights for men who did not own property. He promoted the education of workers through mechanics institutes, free libraries and the co-operative movement. In 1871 he was a member of the first School Board in Newcastle to set up schools for all in Newcastle. In 1867, he built the Tyne Theatre, now opposite his statue, to introduce a wider variety of performances in Newcastle to compete with such established venues as the Theatre Royal. The monument was erected by public subscription in 1906 and was unveiled by Viscount Ridley; the sculptor was John Tweed of London.

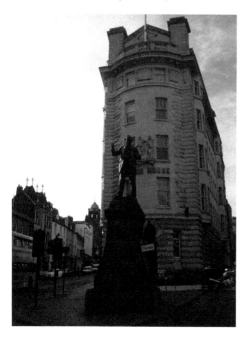

Above left: Joseph Cowen MP was known locally as the 'Blaydon Brick' as he owned brickworks and was also the owner of the *Newcastle Chronicle*. He was a great supporter of freedom fighters.

Above right: Behind the arts centre on Westgate Road, a Roman milecastle was excavated in 1985 and parts of the Roman stones were built into a staircase in Black Swan Yard.

The building at No. 67 Westgate Road, now the Newcastle Arts Centre, was originally built as a town house for Sir Mathew White Ridley of Blagdon Hall. A Roman milecastle was found in 1985 to the rear in Black Swan Yard, and some of the Roman stones have been incorporated into the base of a staircase built following the excavations. A plaque on the wall records that the southwest corner of a Hadrian's Wall milecastle, dating from the second century AD, was discovered on this site in 1985 and that it formed part of the Roman Frontier fortifications of Hadrian's Wall. The discovery of the milecastle in this location came as a complete surprise to archaeologists who were excavating to find evidence of Hadrian's Wall that follows the line of Westgate Road. It was not found in the expected location identified on speculative maps of Hadrian's Wall based upon the position of other known milecastles. The great antiquarian J. Collingwood Bruce, in his legendary Handbook to the Roman Wall (Thirteenth Edition revised by Charles Daniels in 1978), records that 'Milecastle 5 (Quarry House) stood at the junction of Westgate Road and Corporation Street. The site where Horsley recorded vestiges of the milecastle is exactly one Roman mile from the north abutment of Hadrian's Bridge, that is, in the right position the first milecastle of the Broad Wall.' This milecastle is around 730 metres to the east of the expected milecastle and must question the validity of earlier discoveries.

The Hospital of St Mary the Virgin occupied this site from the twelfth century until 1540. The buildings were then used for other purposes until 1607 when the Royal Grammar School, founded in 1545 in a building at St Nicholas' churchyard, occupied the chapel of the former hospital until 1844. The surviving pier stood at the gateway into the Royal Grammar school and has survived a number of redevelopments on the site over the years. The hospital of St Mary the Virgin was also referred to as the 'West Spital' and was founded in the twelfth century to serve God and the poor and to provide accommodation for passing clergy and pilgrims passing through Newcastle. When the town walls were built, the site was split in two and the hospital given a postern gate through the wall to reach their orchards and gardens, which now fell outside the walls close to where the Central Station now stands. When the Royal Grammar School moved to the site, at the request of the Corporation, the chancel was converted into an election house to elect the mayor and town officers. From that time the new mayor used to visit the site each year to collect his staff of office from an old oak table (which still survives in the present school) after the preceding mayor had left it at St Nicholas Cathedral. This tradition continued over the years and became an annual event on 29 September. The boys were given a day off, and they still get a day off today, although the presentation no longer takes place. The boys used to run their own mock election and parade through the town, with their own elected mayor carried high above them. At one time the whole town took the day off to join in the celebrations.

The George Stephenson (1781–1848) Memorial was unveiled in 1862 and was created by J. G. Lough. It not only has George Stephenson standing on top dressed in his Northumbrian Plaid, but has four heroic corner figures in classical dress that represent four of the many aspects of Stephenson's life and career: a platelayer with a piece of George Stephenson's rail; a miner with his patent safety lamp; a blacksmith with anvil; and a locomotive engineer resting on a model engine. The memorial is sited in this location on Neville Street between Newcastle Central Station and the High Level Bridge to reflect the fact that he is

Above left: A pillar from a gateway of St Mary's Hospital, a twelfth-century religious house has survived many redevelopments and still exists opposite St John's church.

Above right: A monument to George Stephenson was unveiled in 1862 with a statue of him on the top and four figures in classical dress below to represent aspects of his life. This figure is holding his 'Geordie' safety lamp used by miners.

generally regarded as the 'Father of the Railways' and that together with his son Robert, who designed the High Level Bridge, they built the first locomotive factory in the world behind the Central Station. George came from a working class background in Wylam and was self taught, working in the mining industry to develop his skills in adapting the design of fixed steam engines to engines on wheels. While working at Killingworth, he developed his early engines on the existing wagonway tracks and kept that gauge measuring 4 feet 8 ½ inches for subsequent engines, and after developing the Stockton–Darlington line in 1825 and the Liverpool–Manchester line in 1829, they became adopted worldwide. Interestingly, it is the same size as the wheels of Roman carts that used to pass through the east gateway at Housesteads Roman fort.

The Literary & Philosophical Society or the 'Lit & Phil' was founded in 1795 as a 'conversation club' by the Revd William Turner. From the outset it included rules such as no talk about religion and politics and had an annual subscription of 1g. It has the largest independent library outside of London and is the third oldest literary and philosophical society in England. In the nineteenth century, it was the centre of intellectual and cultural life attended by Robert Stephenson, William Armstrong, John Collingwood Bruce and many more prominent members of society. In 2011, the actor and comedian Alexander Armstrong

was president and he launched a funding appeal that proved a success and not a 'pointless' gesture as some may have suggested. The present building is by John Green and was built in Classical Greek Revival style, dating from 1825. It was a forward-thinking organisation, with women allowed to join from 1804. Inside is a statue to James Losh, the Radical barrister, sculpted in 1836 by J. G. Lough – the same sculptor who was responsible for George Stephenson's statue opposite. In 1815, George Stephenson demonstrated his safety lamp, known locally as the Geordie lamp, in the then Lit & Phil building. In 1879, Sir Joseph Swan lit the lecture theatre with electricity to become the first public room lit by electricity in the world. The Lit & Phil also own the adjoining building, Bolbeck Hall, designed by Frank Rich, 1909 (who also designed Ouseburn School), and it was used as the coroners' court. The name Bolbeck comes from one of the original estates in Newcastle; another was the Baliol estate.

The North of England Institute of Mining and Mechanical Engineers was established in 1852 and were based in Neville Hall on the site of the former house of the Neville family called Westmorland Place. On top of the decorative roof is a weathervane with a pit pony as a wind vane (instead of a weather cock). The building was built in Victorian Gothic style in 1872 by architect Archibald M. Dunn. The building houses the Nicholas Wood Library. The building also has numerous meeting rooms and a lecture hall, which has been used

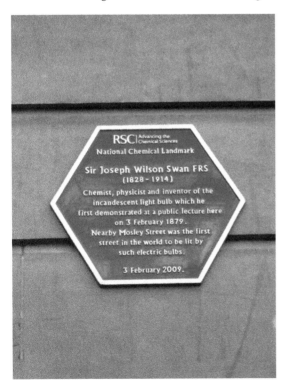

Above left: The blue plaque on the Literary & Philosophical Society premises in Westgate Road records Joseph Swan's demonstration of his incandescent light bulb in 1879.

Above right: The weathervane on the Mining Institute in Westgate Road is a fitting symbol of the industry – the humble pit pony that for many years transported coals underground.

for many years by the Society of Antiquarians of Newcastle to hold its monthly meetings. Westmorland Place was the Newcastle town house for the powerful Neville family who first built it around 1400. It got its name as they were the medieval Earls of Westmorland. The name lives on in Newcastle through Westmorland Street; another name linked to the family is Bolbec Hall nearby on Westgate Road, adjoining the Lit & Phil and built by them in 1909. It is named after the Bolbec family who came originally from Bolbec in Normandy and who owned land near Hexham, which came into the hands of the Neville family in 1410. Neville Street was also named after the family when it was built to link the Central Station to Collingwood Street.

On the wall of the Mining Institute building, fronting on to Westgate Road, is a weathered plaque to record that the original foundations of Hadrian's Wall were found close to the building. The exact position of the Roman remains, that were a few metres below the surface, was marked out in red concrete on the surface of the paved area between the building and the public footpath behind railings around the site. The sign put up in 1952 records that

> Within this plot, covered by red concrete stand the lower courses of the south face of Hadrian's Wall built first in AD 122 from Newcastle upon Tyne to Bowness on Solway and afterwards extended to Wallsend. A distance in all of 80 Roman Miles. The Wall was here 10 feet wide, built with ashlar faces and rubble core and is considered to have been 15 feet high to the rampart walk.

Sadly, the red concrete has now faded, making it is difficult to make out the line of the wall. A further section was found further east on Westgate Road in 2009 when the former Hertz building, previously Coopers Auction Mart, was renovated. The Roman remains were fully excavated and recorded, and are preserved under the present building now known as Cooper's Studio. Coopers business originally auctioned horses, carriages and cycles before cars became commonplace. A rare horse ramp has been preserved within the building, which was originally built to enable horses as well as carriages to reach the upper level to take part in the auction. The building had been under threat of demolition until the Roman remains were discovered, but the listed building was subsequently sensitively restored by Ryder Architects.

On the corner of Westgate Road and Collingwood Street is the very impressive Sun Insurance Building by Oliver, Leeson and Wood, built for the Sun Insurance Co. in 1904. It has a very impressive doorway with two caryatids (classical figures) supporting the lintel above the door. The Edwardian architects certainly knew how to impress with their attention to detail. This is seen in the building on the opposite corner on Collingwood Street, built originally as a hotel but converted into a bank in 1903. Collingwood Street was built in 1810 to link Westgate Road with Mosley Street. Many of the original buildings were replaced by impressive banks and insurance companies when this area became the centre of commerce in the late nineteenth century and the early twentieth century. Today, many are converting to pubs and restaurants with offices above. The Allied Irish Bank building at Nos 9–17 Collinwood Street, built by R. J. Johnson in 1891, was originally a coaching inn called the Turf Hotel and was famous for receiving a large parcel in 1825 that had a body inside – probably destined for Edinburgh surgeons, perhaps from the famous body snatchers Burke and Hare.

Right: On the wall of the Mining Institute is a plaque to record that Hadrian's Wall was found directly in front of the building on Westgate Road, and the line of the wall was marked out in red concrete.

Below: A shining image of the sun is found cast in stone above the former Sun Insurance building on the corner of Westgate Road and Collingwood Street.

Chillingham Wild Bull Plaque, Bewick Street

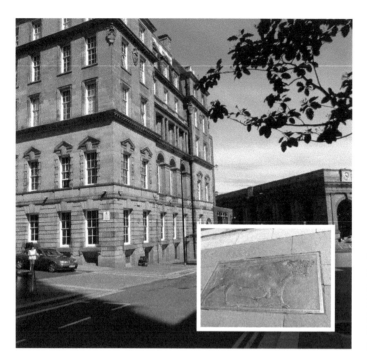

One of Thomas Bewick's famous etchings of the Chillingham Wild Bull is installed on the pavement of his former house or 'little happy cot' on Bewick Street.

One of Thomas Bewick's famous etchings, the Chillingham Wild Bull, engraved in 1789, is represented in a metal plaque on the pavement in Bewick Street next to the site of the building he used to live in. The plaque was made in 2003 and installed by the Bewick Society to commemorate the 250th anniversary of the birth of Thomas Bewick. Thomas Bewick, often referred to as an artist, wood-engraver and naturalist, was born at Cherryburn on the edge of Gateshead in 1753 and died in 1828. He lived in a house, or as he called it, his 'little happy cot at the Forth', from 1781 to 1812 and had his workshop at Amen Corner near the then St Nicholas' church. Bewick was one of Britain's most famous engravers and was a specialist on wildlife. He produced two masterpieces of the day when he published two books – *The General History of Quadrupeds* (1790) and *History of British Birds* (1797). These books introduced many people to animals and birds that were unheard of at the time, and the standard of Bewick's illustrations led to them being seminal works and important teaching aids for years to come. He started as an apprentice to the famous Ralph Bielby – an engraver and printer, who eventually became his partner and whose business he took over in time. He is best known for his skill in engraving on boxwood – a very hard wood that could be printed without the same wear as the copper equivalent. He was famous for his humorous vignettes or tailpieces, which were small, etched cartoon-like pictures used to illustrate pages in a book and that often poked fun at someone. In his *History of British Birds*, Bewick himself is said to be featured in a tailpiece drinking water from his hat.

Cardinal Basil Hume Statue, Bewick Street

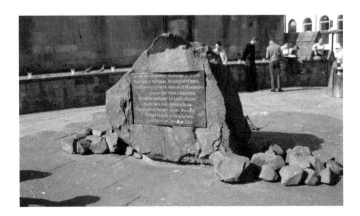

The seventh-century text from the hymn of Caedmon is reproduced as part of the memorial garden for Cardinal Basil Hume behind St Mary's Cathedral.

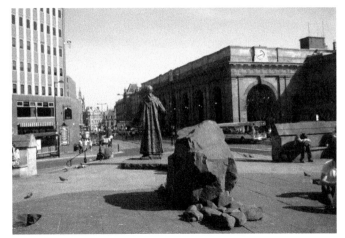

Cardinal Basil Hume is seen here standing on the island of Lindisfarne looking towards the Central Station.

Cardinal Basil Hume was born George Hume in Newcastle in 1923, at Ellison Place, and died in 1999. He started his religious life as a Benedictine monk, rising to become Abbot at Ampleforth. He then progressed to become Cardinal Archbishop of Westminster. The statue and garden were commissioned by the council and people of Newcastle to remember the cardinal, and a site to the rear of St Mary's Roman Catholic Cathedral was an ideal place to provide a remembrance garden. His statue is seen in his Benedictine habit standing on a representation of Holy Island or Lindisfarne, and boulders from the island are also included in the garden as well as a stone from Ampleforth. He is said to have taken inspiration from such saints as St Cuthbert and St Aidan and also produced a book himself in 1966 on the Saints of Northumbria called *Footprints of the Northern Saints*. The garden also includes the text from *Caedmon's Hymn* – the earliest Christian poem in Old English. The memorial garden and statue were designed by Nigel Boonham and the Queen opened the garden on 7 May 2002 as part of her Golden Jubilee celebrations.

Central Station Sculptures Medallions

Three Royal medallions are built into the entrance doorway at the Central Station. They feature Queen Victoria on the right and Prince Albert on the left to commemorate the fact that they opened the station in 1850. Edward VII is in the centre as he opened a bridge named after him in 1906.

The main Central Station was designed by John Dobson in consultation with Robert Stephenson, who built the High Level Bridge. The portico was added later in 1863 by Thomas Prosser (the railway architect from York) to a design based on that of Dobson. The design of the roof over the tracks or the train shed was the first of its type in the world and has been copied extensively since. He used curved wrought-iron fabricated at a specially built rolling mill at the local ironworks, Hawks Crawshay in Gateshead. The curve of the platforms and the vaulted wrought-iron roof won an international prize and are of special architectural merit. Newcastle Central Station was unusual as most large towns had more than one main station. It was also the first station in Europe with all its platforms under cover. The Central Station is also one of the busiest stations in the country as well as being the largest nineteenth-century building in Newcastle. Three towers on the town wall were destroyed to make a site for the Station: Stank Tower (east end of portico) was demolished in 1847; West Spital Tower was demolished with the Hospital of St Mary the Virgin in 1844; Neville or Denton Tower, named after the Neville's, Earls of Westmorland, was demolished in 1848. Inside the entrance doorway into the station are three royal medallions looking down on passengers. Queen Victoria on the right and Prince Albert on the left officially opened the station on 29 August 1850, but the date above them says 28 September 1849; presumably an earlier visit was postponed for some reason. The central figure is of their son Edward VII, who visited the station in 1906, opening the railway bridge named after him. There is also a blue plaque on one of the pilasters below to commemorate the present Queen's visit on 7 December 2000 to celebrate the stations 150th anniversary.

Clock, Guildhall, Sandhill

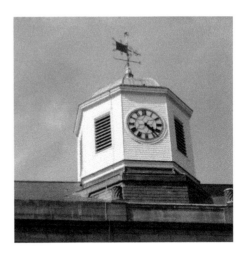

The clock on the guildhall was installed in 1796 during one of the many alterations to the building that served as the guildhall/town hall from medieval times to the nineteenth century.

The guildhall was Newcastle's first town hall, which was the original administrative centre for the town and was the headquarters for the Newcastle Guilds and the original law courts. It was first built in 1425 when Roger Thornton built the hospital of St Catherine for nine poor men and four poor women , later known as *Maison de Dieu* (house of God) on the east end of the building, above which was the Merchant Ventures' Court. Robert Trollope rebuilt the guildhall in 1658, which included a large extension to the west and the introduction of a decorative staircase leading to both the *Maison de Dieu* and the guildhall. He also built a new courtroom and meeting rooms for the mayor, sheriff and aldermen to meet in. The guildhall was damaged in 1740 when the Keelmen rioted and ransacked the building and stole the town's hutch or money chest. In 1791, it suffered from fire damage. The council decided, in 1796, to carry out extensive alterations involving the complete reconstruction of parts of the building, giving it its present Georgian appearance. The building was later altered by some of the famous architects of Newcastle including William Newton and David Stephenson in 1796 (who included the clock cupola), John Stokoe in 1809 and John Dobson in 1825. Dobson replaced various dangerous structures, including the former hospital, with a new east section including a covered colonnaded fish market. This, at first, was not popular with the fishwives who had previously operated out in the open. However, following a period of inclement weather, they eventually adopted the sheltered area. The Laing Art Gallery has a painting of the fishwives occupying this space under the guildhall; it was painted by John Dodson between 1823 and 1830 and is called *The Old Fishmarket, Sandhill.* In 1898, Dobson's fish market was sensitively blocked in to form internal accommodation when the new fish market opened under the High Level Bridge. The interior of the guildhall and especially Robert Trollops courtroom has been featured a number of times by filmmakers as well as being used by Newcastle City Guides to recreate famous courtroom scenes such as the witches' trials of the late 1600s.

Bessie Surtees House, Sandhill

The most impressive timber-framed house in Newcastle was made famous by the elopement of Bessie Surtees to marry the future Lord Chancellor of England, John Scott.

Bessie Surtees House on Sandhill is one of the finest groups of timber-framed houses in Northumberland and Durham, and most date from the 1650s, although some have a brick skin on them. Bessie Surtees house is the widest and is English Heritages' northern headquarters. It was bought by the city council in 1982 and was fully restored by 1989. The house is famous for being the home of Bessie Surtees, a merchant's daughter who famously eloped with John Scott, later to be the first Earl of Eldon and Lord Chancellor of England. She climbed out of a first floor window, marked by a plaque on the building, by a ladder on 18 November in 1772. She was supposed to marry a rich friend of her father who was in his sixties, but she had other ideas and ran off to Scotland to get married to John Scott, who appropriately lived in Love Lane further along the Quayside. It is said that her father Auburn Surtees later forgave Bessie and they got married again in St Nicholas' church. The group of houses were built at the foot of the steep hill rising up to the castle. Most are five-storeys high and many had large expanses of glass in them to reflect how rich the occupants were (glass was at one time very expensive and at times there were also window taxes).

Swing Bridge Plaques

Built into the sides of the swing bridge are two plaques; one has the crest of Newcastle on it and the other featured here has the crest of the River Tyne Improvement Commission, who paid for the bridge to be built in 1876.

The Swing Bridge was built by William Armstrong between 1873 and 1876 on the site of the former Georgian bridge. It was built to enable shipping to reach Armstrong's armament works and shipyards at Elswick and Scotswood. It was commissioned by the Tyne Improvements Commission as part of their overall strategy to make the Tyne more navigable along a much greater length including beyond the major obstacle to shipping, the Georgian Bridge built in 1781. Part of one of the original Georgian bridge arches still exists under the coroners offices. At the time, the Swing Bridge was the biggest moving bridge in the world and the first to use hydraulic power. It weighed 1,500 tons and was 90 metres long, with 30-metre wide openings to allow ships through. The biggest ship to go through was HMS *Canada* at 32,000 tons in 1914. In its busiest year, in 1924, around 6,000 ships passed through each way with a total tonnage of 6,327,847. The Swing Bridge was originally a toll bridge for shipping and paid for itself by 1893, in just seventeen years, as it was so busy on the river. There are two sets of coats of arms on the side of the Swing Bridge either side of the pedestrian arch. The one to the north is the Newcastle coat of arms, with three castles and the motto *'Fortiter Defendit Triumphans'* which translates as 'Triumphing by a brave defence' and was bestowed on the town by Charles II after the Restoration of the monarchy. The second coat of arms is the Tyne Improvement Commission's coat of arms, set up in 1850 to improve navigation on the River Tyne. It includes the three castles representing Newcastle, three crowns representing Tynemouth, a gatehouse representing Gateshead and a boat manned by rowers with the sign 'Always Ready' representing South Shields. The motto *'Servat Vigilantia Concors'* means 'united vigilance serves to protect'.

Neptune Sculpture, Fishmarket

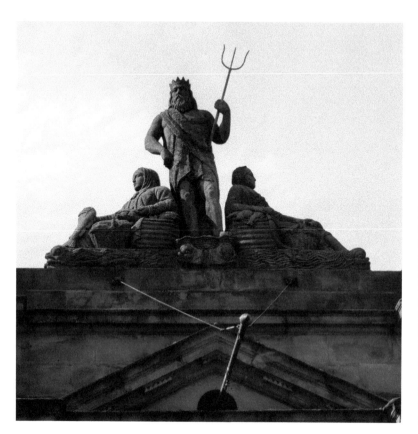

Neptune and two fishwives are featured on the former Fishmarket building situated below the High Level Bridge. A Roman altar to Neptune was found nearby in the river in the 1870s.

The fish market was built in 1880 and was designed by A. M. Fowler. It replaced an earlier market that occupied the eastern side of the guildhall that had been designed by John Dobson. The market, built for Newcastle Corporation, was not a success and it was closed around 1900. The building has some very interesting architectural details including decorative metal door grills incorporating the Newcastle coat of arms and a number of decorative stone urns. On the centrepiece above the main door, facing the river above the fish market sign, are sculptures of Neptune and two local fishwives. A Roman altar to Neptune was found close to the Swing Bridge when dredging took place in the nineteenth century. The inspiration for the fishwives comes from the traditional dress of those from coastal villages such as Cullercoats, carrying a basket or creel of fish on their back. At one time, fishwives were banned from travelling to Newcastle on the train from Cullercoats as some of the wealthy businessmen objected to sharing a carriage with them and their creel full of fish. After the intervention of the local newspaper, a compromise was arrived at and they were allowed back on the trains, but only after 9.30 a.m. in the morning when most commuters would have already gone to work.

Kittiwakes, Tyne Bridge

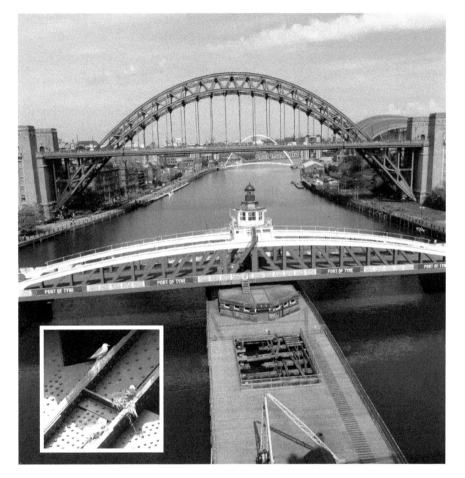

The iconic Tyne Bridge is famous for supporting the world's furthest inland colony of breeding Kittiwakes. These protected seabirds nest here between March and August.

The Tyne Bridge, opened in 1928 by George V, is famous for a number of reasons. It was the longest bridge of its type in the world, before Sydney Harbour Bridge was completed five years later. It is also famous for having the world's furthest inland breeding site for Kittiwakes. The birds first arrived in the 1950s as the river was improved, and the colony has continued to expand as the river has become cleaner. The birds normally nest on high cliffs – their long claws are well adapted to living on ledges and they quickly found parts of the bridge an ideal nesting ground safe from predators. The nests are made from seaweed and other material held together by mud. The birds nest between March and August and can raise up to three white fluffy chicks. They then spend the rest of the year out at sea and can travel as far as Canada. They get their name from their distinctive call – 'kitti-wa-aaake' – and they were first protected many years after they had been threatened with extinction in Victorian times when their feathers were in great demand for ladies' hats.

Tyne-Tees Sign, King Street

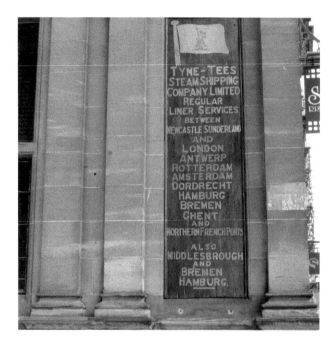

On the corner of Kings Street and Quayside is a sign from the past advertising the ports served by the long-departed Tyne–Tees Steam Shipping Co.

On the corner of Kings Street and Quayside is a sign from the past. It advertises a company called Tyne-Tees Steam Shipping Co. Ltd., who operated regular liner services from the Tyne to a wide range of destinations from Newcastle. These included London, Antwerp, Rotterdam, Amsterdam, Dordrecht, Hamburg, Bremen, Ghent and various French ports. The company also had offices in Middlesbrough, Bremen and Hamburg. This sign had stood neglected for a number of years after the company ceased to exist, but a campaign was launched, by the Northumberland and Newcastle Society, to restore the sign to its former glory, which was carried out successfully a few years ago. The company also had another office near the Ouseburn and that building has been renovated in recent years and is now the Hotel Du Vin; it also has a restored sign relating to Tyne-Tees Shipping Co. within it. Along the riverside at one time, different wharfs were dedicated to different destinations, for example, in 1894, between the guildhall and Swirle there were wharfs named after Aberdeen, Leith, Hull and London. All the buildings between the guildhall and the custom house were rebuilt in the late 1850s, to an overall layout by John Dobson and many formed the first purpose built commercial offices for shipping companies. In October 1854 a fire started in Gateshead and spread to Newcastle due to sparks and from explosions. Many houses on the Newcastle side were of timber construction, like Bessie Surtees House, the Red House and the Cooperage with narrow alleys or Chares separating them. All the housing from the guildhall west to the customs house, including six *chares*, were destroyed and the devastation extended as far back as Pilgrim Street.

Customs House, Quayside

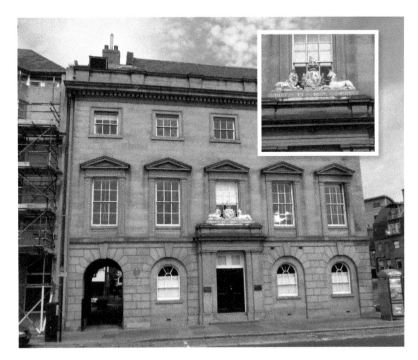

A very impressive Hanoverian coat of arms is found above the former customs house on the Quayside. The building dates from 1760, but was modernised and refaced in 1833.

Before 1760 the customs house was nearer west end of the Quayside at Sandhill. It was moved to its present site in that year when the town walls along the Quayside were demolished. The building was later modernised, being refaced in Palladian ashlar in 1833 by the architect Sydney Smirke, brother of the architect Sir Robert Smirke, and son-in-law of John Dobson. The royal coat of arms over the door is one of only two of the Hanoverian type in Newcastle, which were used up to1837 when Queen Victoria came to the throne; the other can be seen on the Theatre Royal. The building had a narrow escape during the Great Fire of Gateshead and Newcastle in 1854 when all the buildings to the west of the present building were lost to the fire. The customs house is now in use as a barristers chambers, being situated not far from the court buildings on the Quayside. The archway leading below the building, near the west side, is called Custom House Entry and gives pedestrian access to the rear of the building. A few metres to the west is another passageway called Fenwick Entry. On the wall is a blue plaque to say that Thomas Spence (1750–1814), the famous Newcastle campaigner against exploitation and oppression, established a schoolroom and debating society there when it was called Broad Garth. He was born on the Quayside and is described as being a 'utopian writer and land reformer' and 'courageous pioneering campaigner for the rights of men and women'. Underneath are the words 'Dare to be Free', which demonstrates the commitment of Thomas Spence, who spent a number of years in prison as a result of his convictions.

Broad Chare

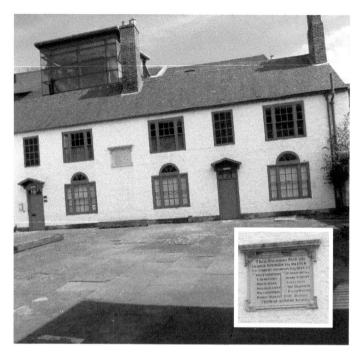

The almshouses were built in 1782 and were linked to a number of other buildings operated by Trinity House, who were responsible for improving navigation on the River Tyne and beyond for many centuries.

Trinity House almshouses were built in 1782 and form part of a complex of buildings on Broad Chare run by Trinity House, one of the original companies in Newcastle, established in the early sixteenth century and given a Royal Charter by Henry VIII in 1536. Trinity House were responsible, initially, for improving navigation up the River Tyne to Newcastle as the river was shallow and full of sandbanks, and could even be forded at low tide close to the centre of Newcastle. They were allowed to impose a toll of 2d on all ships using the river, or 4d for foreign ships, which was used to carry out improvements to the river. In time they gained additional responsibilities and built lighthouses at the mouth of the Tyne at North Shields to safely guide ships into the river. These lighthouses still survive as the High and Low Lights together with their predecessors. Further powers were granted to Trinity House and they eventually had responsibility for the whole coastline from Berwick to Whitby. They had responsibility to provide buoys and beacons, carry out improvements to river navigation and to ports as well as licensing mariners, mates and pilots. At Trinity House, beside the main administrative buildings in Newcastle, they built a school to train and examine mariners and pilots, a chapel and almshouses. Over time many of the responsibilities have been passed on to other organisations, the major change coming about when the Tyne Improvements Commission was set up in 1850. The River Tyne was extensively dredged and narrowed and work commenced on building the two main piers at North and South Shields.

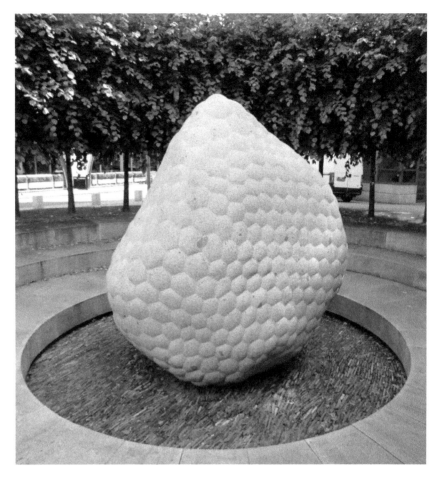

This massive artwork is situated at the north end of Broad Chare above the buried watercourse of the Pandon Burn. It is carved out of a 36-ton glacial boulder with 360 hexagons and twelve pentagons.

Underground at this point is the Pandon Burn, another of Newcastle's lost burns or river tributaries. The area was known as the 'Vale of Pandon' and at one time would have been an attractive wooded valley not unlike Jesmond Dene. By the late 1200s, it had developed into the township of Pandon, built up around industries such as boatbuilding either side of the Pandon Burn, and was navigable for some distance from the River Tyne. Many other noxious industries, such as tanning, developed around the congested riverside and the area was one of the most densely populated and unhealthy places to live in Newcastle. During the building of the town walls, around 1300, a diversion of the wall was approved to incorporate the township of Pandon. On City Road above Broad Chare is the 'Corner Turret', which still survives and shows the 90-degree turn in the direction of the wall that was originally designed to run down Broad Chare. Today, there is an impressive sculpture, installed above the Pandon Burn in 2005, to form a centrepiece of a new open space in the former 'Vale of Pandon'. It is called *Give and Take* and was carved by Peter Randal Page from a 36-ton glacial boulder from the Fort William area of Scotland. The natural shape was retained, but the sculptor carved out 630 hexagons and twelve pentagons on its surface, based on designs seen in the natural world in cellular, atomic and molecular structures.

Wesley Square

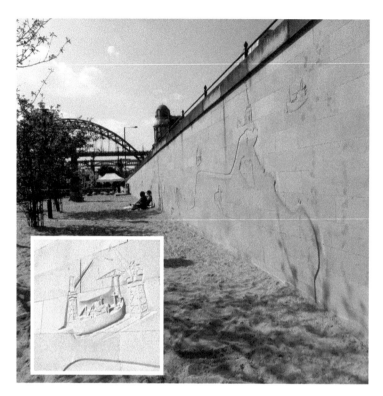

Carved onto the wall of the north wall of Wesley Square is a depiction of the River Tyne from Tynemouth to many miles inland. Many features along its route are carved also, including bridges, buildings and shipbuilding at Swan Hunters, Wallsend.

In the early 1990s, the area of riverside to the east of the customs house and Broad Chare was run down, becoming derelict in parts through the decline of the traditional riverside industries largely based on riverside wharfs and warehousing. A site for new law courts was set aside to the east of Broad Chare. The Tyne & Wear Development Corporation was set up to tackle industrial decline on Tyneside in 1987 and this area was targeted for improvement. The area known as East Quayside was designed by Terry Farrell & Partners in their Master Plan adopted in 1992. It was to be an area of offices, pubs/restaurants and leisure units using brick and sandstone, with no strict design guidance, but incorporating hard landscaping and public art. Road improvements took place and a new retaining wall, sited on the line of the original town wall, was built in front of a new open space called Wesley Square, and John Wesley's drinking fountain was installed as a centrepiece. The sandstone faced wall presented an opportunity for public art and Neil Talbot carved an image of the River Tyne into the wall at Wesley Square showing features such as Cawfields Milecastle, Bardon Mill, Haydon Bridge, Corbridge, Cherryburn, Prudhoe castle, George Stephenson's Cottage, Lemmington Glass works, Dunston Staithes, High Level Bridge, Tyne Bridge, Swan Hunters, St Pauls Monastery, Arbeia Gateway, Tynemouth priory and a trawler called *Talbot*.

John Wesley first preached in Newcastle in the Milkmarket in 1742. A drinking fountain was erected close to that spot in 1891, which was relocated to a new Wesley Square following improvement works in 1996.

Wesley Square forms an integral part of the regenerated East Quayside area. The link roads between the Milkmarket area and Quayside had to be realigned and a fountain in John Wesley's memory had to be moved. It was repositioned at a lower level close to its original position in Milkmarket, and the new open area around it was named Wesley Square (opened in 1996). John Wesley visited Newcastle in the 1700s and used to preach in this part of town as it was one of the most deprived at the time. In 1742, on his first visit, he described it as 'the poorest and most contemptible part of the town'. It is said that he was saved from the crowd by one of the fishwives when the crowd got upset by his preaching. This did not put him off, and he set up an Orphan House in Northumberland Street and later founded Methodism, although he was never a Methodist himself. The granite obelisk water fountain includes drinking facilities for humans, horses and hounds. It was first erected in the Milkmarket in 1891 to mark the centenary of Wesley's death and was the gift of Utrick A. Ritson, a Methodist businessman in Newcastle. It records his first sermon in Newcastle on Sunday 30 May 1743, 'He was wounded for our transgressions; he was wounded for our iniquities; the chastisement of our peace was upon him; and with his stripes we are healed.' John Wesley loved Newcastle and on 4 June 1759 wrote in his journal, 'I rode to Newcastle. Certainly if I did not believe there is another world, I should spend all my summers here, as I know no place in Great Britain comparable to it for pleasantness.'

Quayside

The River God torso is situated above a large column looking towards another female figure called Siren standing at the top of the Sandgate Steps. These artworks were installed as part of the east Quayside redevelopment in the mid 1990s.

The River God stands in the middle of a vehicle turning circle between the Millennium Bridge and the Malmaison Hotel, at the foot of Sandgate Steps. *The River God* is a male figure, with a torso and head only, sitting on top of a tall steel column. He appears to be blowing at another similar sculpture of a woman, named the Siren, who is situated at the top of the stairs. The bronze figure is patinated brown and holds a staff with a spiked ball at its head and his other hand, behind his back, is holding a chain that hangs below the torso. The work is by Andre Wallace who also produced the Siren on this area of East Quayside, which is rich in public art. The staircase itself, known as Sandgate Steps, is a work of art using decorative railings in the shape of ropes and waves. At the top of the stairs there are more carvings including the words of the famous local Keel Row song. Neil Talbot and Graciela Ainsworth have also carved images of the famous keel boat and the Keelmen on one side and ominously a carving of the mechanical Coal Drops that led to the demise of the Keelmen on the other side. The Keelmen traditionally lived in Sandgate outside the town walls and close to the Keelman's Hospital on City Road that was paid for by the Keelmen themselves in 1701. Two further Lighthouse installations by Cate Watkinson, similar to the one at Wesley Square, are found at the top of the stairs. The pieces of art on the Quayside were funded by the Tyne and Wear Development Corporation in 1996 as part of the Quayside regeneration.

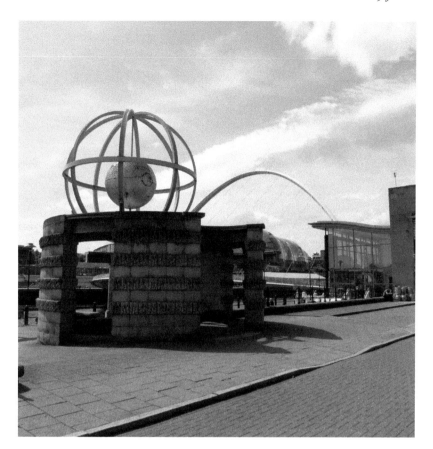

The Swirle Pavilion is another artwork beside the Millennium Bridge which forms an open pavilion, incorporating the names of many ports formerly served by ships leaving Newcastle.

The Swirle Pavilion, which is both a sculpture and a building, is sometimes referred to as a folly as it looks like a shelter with seats but does not have a roof. It was designed by Raf Fulcher, who at the time taught at Sunderland University, in 1998 at a cost of £46,000 and was commissioned by Tyne & Wear Development Corporation. Inside, around the upper part of the support, there are the names of some of the ports that used to trade with Newcastle. These include Rotterdam, Copenhagen, Hamburg, Genoa, Aberdeen, Antwerp, Malmo, London and Hull. Some of the names are the same as those on the restored signboard at King Street. They were the major destinations of the Tyne-Tees Shipping Co. Ltd in the nineteenth century. The Swirle was a stream that used to join the Tyne at this point and still exists, under the surface, discharging into the River Tyne close to this point. Behind the Pavilion is a new office block called St Ann's Wharf, which has a striking U-plan block designed by CZWG Architects LLP. Close by are two further sculptures, the bronze *Rudder* and the steel and stone *Column and Steps*, both by Andrew Burton dating from 1996. The *Pitcher and Piano* was designed by Panter Hudspith – an architect originally from Newcastle. The Malmaison Hotel was named after Napoleon's first wife Josephine's home in France. It was originally built as the Cooperative Wholesale Stores (CWS) warehouse in 1900 and is one of the first reinforced concrete buildings using the Hennebique method (the oldest survivor in Britain). It was converted to a hotel in 1990s and is a listed building.

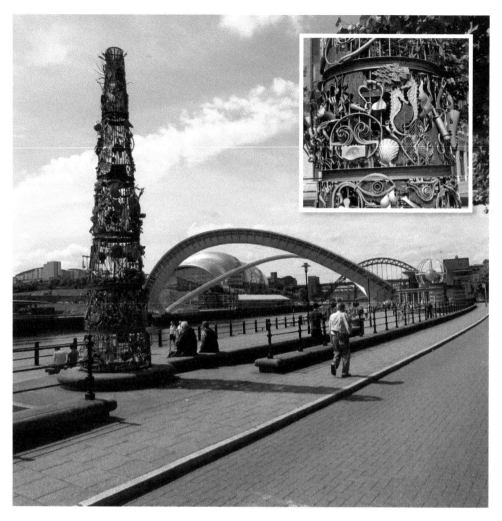

This is one of the most impressive sculptures on the Quayside and features the work of blacksmiths who have represented the six senses by a number of objects representing different senses, some more obvious than others.

One of the most striking, impressive and engaging artworks on the Quayside is the *Blacksmiths Needle*, which stands on a plinth set back from the riverside in front of St Ann's Wharf – one of the new office blocks built as part of the East Quayside redevelopment. It was commissioned by Tyne & Wear Development Corporation and was launched in 1997 by Evelyn Glennie, the percussionist, ringing a bell that hangs inside the needle. It was designed and constructed by the Blacksmiths Association of Blacksmith Artists in public 'forge-ins' in 1997. It is a six-segment cone made up of different objects, with a maritime theme representing the six senses of touch, sight, taste, smell, sound, and the mysterious sixth sense occupies the top section. Some of the objects are obviously and directly linked to the senses; some are very obscure with a tenuous link.